PHOTOGRAPHY

Andrew Gregory

Media Resources Officer, Archbishop Tenison's School, London
formerly Photography Teacher, Thomas Calton School, London

Mark Trompeteler

Media Resources Officer, ILEA Design and Technology Centre
Photography Tutor, Cowley Recreational Institute, London

Longman

Photographs showing Praktica cameras, accessories and components and Pentacon lenses and equipment have been kindly supplied by C.Z. Scientific Instruments Ltd.

Some photographs by pupils of Thomas Calton School, Peckham, are featured. All other photographs by the authors.

The authors acknowledge the advice and assistance of Ernie Scott during the preparation of the book.

We are grateful to the Kodak Museum for permission to reproduce the figure on p.9. Photographs on pp.15, 26, 46 and cover by Longman Photographic Unit.

LONGMAN GROUP LIMITED
*Longman House, Burnt Mill, Harlow, Essex CM20 2JE, England
and Associated Companies throughout the World*

First published 1985
ISBN 0 582 23503 0
Produced by Longman Group (FE) Ltd
Printed in Hong Kong

Contents

Introduction

More and more schools, colleges and establishments of further education are catering for the growing interest in photography by introducing examination courses. These examination courses reflect the enormous increase of interest in photography as a leisure activity and as a possible career. Photography is now widely regarded as a subject in its own right rather than as an adjunct to a science or art course.

There are many excellent books available on photography. This book has been written specifically to meet the needs of the secondary school CSE, 'O' level and 16+ examination candidates. We hope that others seeking a basic introduction to the subject will also find it valuable.

The book provides a basis on which to explore some of the many practical aspects of the subject, with a core of concise notes useful for reference and revision. Although each section is intended to lead logically into the following one it is possible to move about within the framework of the book.

The subject of colour photography has been intentionally ignored as it is not included in most CSE courses. This is not solely for reasons of economy. Colour can be a very distracting factor when learning the basics of composition and image manipulation. A photographer who has to work within the disciplines of black and white photography will find that it has its own satisfying qualities.

Why study photography?

Photography is unique in that it is both an art and a science. The photographer must combine the artistic disciplines of 'seeing', composing and working with an image with the methodical and systematic procedures of a scientist. Furthermore, as a good 'craftsman', the photographer must master the tools of the trade: the mechanics of the camera, the qualities of photographic materials and the properties of light and lenses. This might make photography sound daunting, yet the basic principles can be grasped quite quickly. Once grasped, mastering them can provide many years of fascinating and enjoyable activity.

Photography has made an enormous impact on our everyday life in the twentieth century. It has become a universal language for communicating visual information. We no longer accept the theory that the camera cannot lie. A picture is still worth a thousand words when it comes to showing us things, either as they are or as others would like us to see them. This is why newspaper editors and advertising executives have used it as a tool both to inform and influence us. Photography provides valuable historic records of world events and everyday life. It is an indispensable tool in many aspects of science and research. A knowledge of photography can also lead to a better understanding of the equally influential media of film and television.

A photograph can capture a moment in time and can provide a record of personal and family events. Producing photographs is a way of expressing yourself. You can capture or create a mood or effect. Alternatively, you can exploit photography's unique ability to record and reveal even the smallest detail. It can be enjoyed either as an individual or a group activity. It can be combined with existing personal interests – for example, a train spotter could take photographs of locomotives. Photography can also awaken an interest in new subjects such as photographing the countryside or photographing people. Studying photography to an advanced level can lead to a worthwhile career or a lifetime interest.

Chapter 1

Discovering basic principles

Pictures without a lens

Although photography is a relatively modern process, it was not invented suddenly but evolved from many people's experiments and discoveries over the centuries.

In 1802 Thomas Wedgwood (son of the famous potter, Josiah Wedgwood) was making simple outline or **silhouette** pictures of fern leaves on light-sensitive paper. He made the paper sensitive to light by soaking it in silver nitrate solution.

Practical things to do . . .

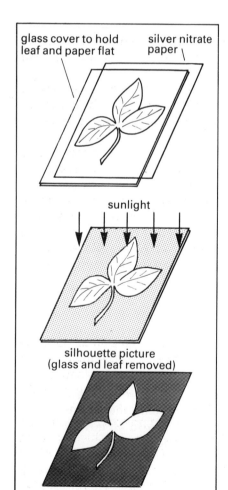

glass cover to hold leaf and paper flat

silver nitrate paper

sunlight

silhouette picture (glass and leaf removed)

1 *a* In a darkroom prepare three dishes: one of **developer**, one of water and one of **fixer**. Turn on the **safelight** and turn off the white room light.

b Place three small pieces of photographic paper on the bench, light-sensitive coating upwards. Place a coin on top of each.

c Turn the white room light on. Remove a coin from one piece and observe the changes taking place in both this and the other two pieces of paper. The coating is reacting to light.

d Turn the room light off again, and place the other two pieces of paper in the developer for two minutes with just the safelight on. The paper will turn black except for the area masked by the coin which remains white.

e Rinse the two pieces of paper in the water. Then place one in the fixer and leave the other in the water.

f After two minutes, turn the white room light on again. The paper in the water will turn completely black. The piece of paper in the fix will remain unchanged. The image is permanent or 'fixed'.

What three principles have you learned from this experiment?

Thomas Wedgwood made a simple picture by placing a leaf in close contact with light-sensitive paper and bringing it out into the sunlight. The paper turned black where it was exposed to sunlight and remained white under the parts protected by the leaf.

2 *a* Place a sheet of thin photographic paper in a masking frame with just the safelight on. Place an object on top of the paper – for example, a bunch of keys.

b Flash the white light from an **enlarger** on to the paper for about 15 seconds with the enlarger lens set at f 8. The best **exposure** to light may have to be determined by trial and error.

c Develop and fix the paper. On the paper you will have an image that is called a **negative** – the original tones have been reversed, so that the shapes are white on a black background.

d Wash and dry this **print** (a piece of photographic paper on which there is an image).

e Place a new sheet of paper, coated side up, on the baseboard. On top of this place the negative print, image (or coated side) down. In order to keep the two sheets in contact, place a piece of clean heavy glass on top.

f Expose the 'sandwich' of prints to light. Try doubling or trebling the original exposure. This technique is known as **contact printing**.

g Develop and fix this print. The resulting print is a **positive** image of the keys – black shapes on a white background. It is also a mirror image of the first negative print.

Simple silhouette pictures like these, and those made by Wedgwood, are called **photograms**. They provide a method of making a simple picture without a camera.

Endless variety can be introduced into the simple exercise of making photograms. Make a collection of objects to use. Look for variety of shape, transparency, size and depth. Dried flowers, leaves, feathers and paper doilies are some suggestions.

You will notice that three-dimensional objects give an effect of tone at the edges. Try exposing for half the normal time, then take some objects away, move others slightly, and complete the exposure.

Objects such as netting, feathers and scientific specimens can be placed in the enlarger's negative carrier and used to produce interesting images. Chapter 9 contains further techniques that can be applied to making photograms. To be really successful, this technique, like many others in photography, benefits from experimentation.

The earliest camera

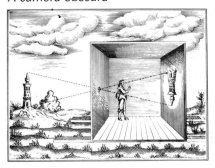

A camera obscura

Light travels in straight lines. If light passes through a small hole, the rays can be collected and projected to form an upside-down image. This principle was used in the earliest **camera obscura** (Latin for a dark chamber). This was a device used by artists to enable them to make accurate drawings from which they could produce paintings.

The camera obscura was the basis of the first practical camera. The one important addition was the placing of a light-sensitive plate on which the image would form at the rear of the camera. In 1826 a Frenchman, Nicéphore Niépce, obtained a photographic image using a camera like this. The exposure time was eight hours. It is very easy to make a simple working camera that uses a pinhole instead of a lens.

Practical thing to do . . .

Make your own **pinhole camera**. You need a stout cardboard box.

Make sure that the box is light-tight. Under safelight conditions in the darkroom, stick a piece of photographic paper to the back flap. Close the camera up and seal it tight with tape.

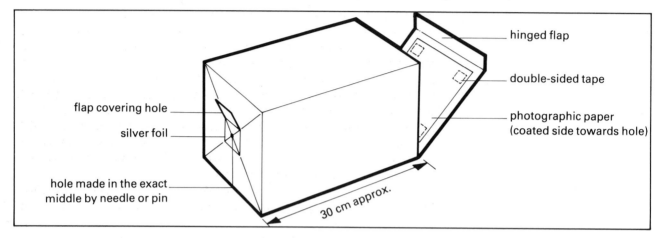

flap covering hole

silver foil

hole made in the exact middle by needle or pin

hinged flap

double-sided tape

photographic paper (coated side towards hole)

30 cm approx.

Take the camera outside. Place it on a solid surface and point it at the subject. Carefully uncover the pinhole and start timing: try an exposure time of two minutes on a sunny day. The correct exposure for varying light conditions is usually determined by trial and error. Do not move the camera during the exposure. Cover the pinhole and return to the darkroom.

Develop and fix the paper. If your exposure time was correct, you should achieve a negative, ghost-like image of your subject. Contact print this to get a positive image. If your print is too light, increase the time; if too dark, decrease the time.

You will notice that any movement of the subject will give a blurred image. Movement of the camera during exposure will probably give a double image. Because of the long exposure time it is possible for someone to walk past in front of the pinhole and not appear on the negative.

The pinhole camera is similar to a more advanced camera, both in its basic parts and principles.

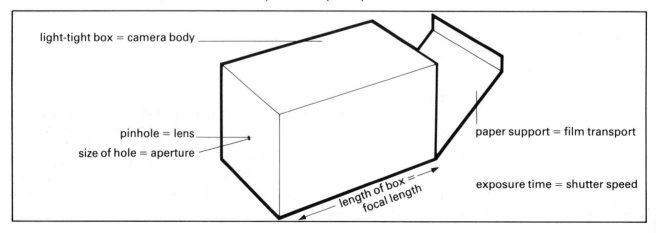

light-tight box = camera body

pinhole = lens

size of hole = aperture

length of box = focal length

paper support = film transport

exposure time = shutter speed

Chapter 2

Cameras and films

The basic camera

A modern camera has all the basic parts of a pinhole camera, except that a **lens** replaces the pinhole. A simple lens is a disc of glass that has been shaped and polished. It will bend a set of parallel light rays so that they meet (focus) at a point (the **focal point**). The light rays travelling to the lens from a distant object are almost parallel, and an upside-down (and left–right inverted) image of the object is produced on the **focal plane**. The distance between the focal plane and the centre of the lens is called the **focal length**. If the object is close to the camera, the light rays are not parallel, and the image is formed in a different place. Many modern cameras allow the lens to be moved backwards and forwards so that the image can be **focused** on to the film.

A lens with a focal length of about 50 mm is often called a **standard lens.** The focal length is engraved on the front of the metal lens housing (**lens barrel**).

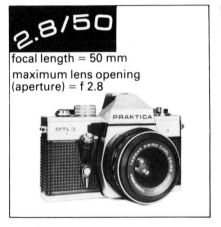

focal length = 50 mm

maximum lens opening (aperture) = f 2.8

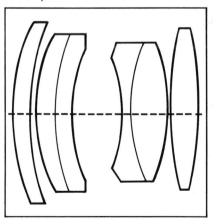

A compound lens of six elements

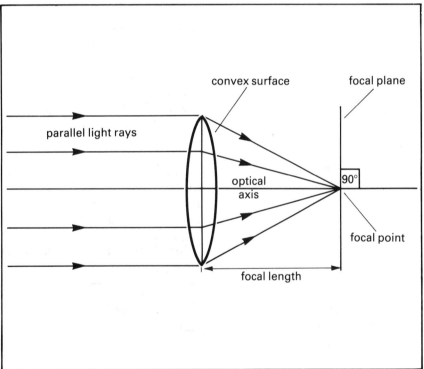

A **simple lens** is not perfect and does not form a very sharp image. A modern camera lens is made up of several lenses (or **elements**) of different shapes, sizes and thicknesses. These cancel out each other's imperfections (**aberrations**) to form a much sharper image. This system is known as a **compound lens.** Nearly all modern camera lenses have a **coating** of magnesium fluoride to cut down unwanted reflections (**flare**).

Basic parts of a modern camera

The diagram shows the basic parts that are found in all cameras, whether simple or advanced.

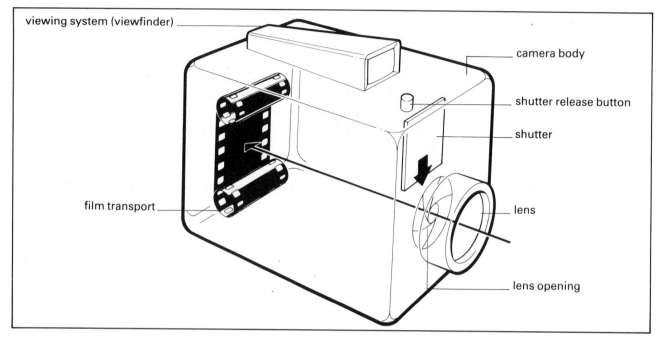

The camera body is a light-tight box.

The **shutter** stops light reaching the film except when taking a picture. When the **shutter release button** is pushed fully down, the shutter opens to allow light to pass through the lens on to the film. The shutter can vary the amount of light by the length of time it stays open.

The lens focuses light on to the film to form an image. It can be moved backwards and forwards to adjust the focus.

The lens opening is also known as the **aperture** or **stop.** The size (or diameter) of the aperture can be changed by moving a set of circular blades called the **iris diaphragm.** This also changes the strength of light falling on to the film.

The **viewfinder** offers a way of seeing and arranging what you are going to photograph.

The **film transport** moves the film and holds it flat on the focal plane. The special light-recording side of the film (the emulsion) faces the lens.

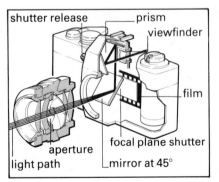

Reflex viewing system

It is a great help if what you see through the viewfinder is exactly what is recorded on the film. In the **single lens reflex** (SLR) camera, this is done by using a hinged mirror. This mirror reflects (hence 'reflex') the image up through a five-sided prism. The **pentaprism** turns the image the right way up and reflects it into the viewfinder.

The sequence of operation is as follows:
1 The shutter is released.
2 The iris diaphragm closes to the right aperture.
3 The mirror flips up.
4 The shutter blind travels across the film, exposing the film to light rays. The shutter returns; the mirror returns; the diaphragm returns. This all takes place in a fraction of a second.

The 35 mm single lens reflex camera

This is a very popular, compact and portable camera which uses 35 mm film. There are two main advantages with this type of camera. Firstly, the image you see in the viewfinder is exactly the image recorded on the film, whatever the distance of the subject. Secondly, this type of camera has the shutter (**focal plane shutter**) directly in front of the film or focal plane. This stops light from spoiling (**fogging**) the film if you unscrew the lens. This means that you can fit lenses of differing focal lengths on to the camera body, which makes the camera adaptable to different picture-taking situations.

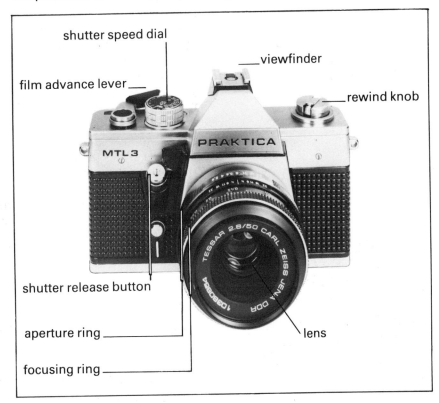

A 35 mm single lens reflex camera

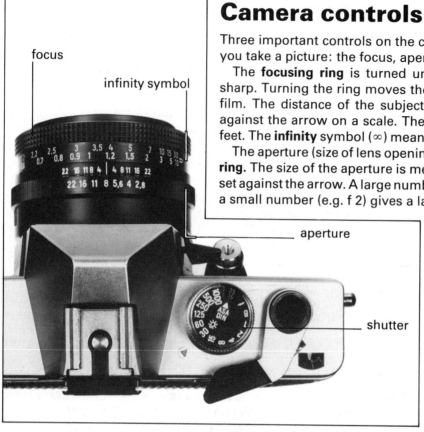

focus

infinity symbol

aperture

shutter

Camera controls

Three important controls on the camera must be correctly set before you take a picture: the focus, aperture and shutter controls.

The **focusing ring** is turned until the image in the viewfinder is sharp. Turning the ring moves the lens further from or nearer to the film. The distance of the subject from the camera can be read off against the arrow on a scale. The distances are given in metres and feet. The **infinity** symbol (∞) means 'as far as the human eye can see'.

The aperture (size of lens opening) is altered by turning the **aperture ring.** The size of the aperture is measured in f numbers. These can be set against the arrow. A large number (e.g. f 16) gives a small aperture; a small number (e.g. f 2) gives a large aperture.

The shutter controls the length of time that light reaches the film. By turning the **shutter speed dial** you can alter the time for which the shutter stays open. The numbers on the dial are fractions of a second. A slower shutter speed (lower number, e.g. 30) set against the arrow lets more light in than a faster number (higher number, e.g. 250). When the dial is set on B, the shutter remains open for as long as the shutter release is pressed. On some makes of camera the shutter speed is set on the lens barrel.

Some advanced types of 35 mm SLR cameras can be semi-or-fully automatic. This means that the aperture and/or shutter will work without you having to set the controls manually (by hand).

Practical things to do . . . with the help of your teacher

1 Open the back of the camera; tape a piece of tissue paper over the shutter frame. Point the camera at a window and open the shutter using the B setting. You will see an inverted (upside-down) image on the tissue.
2 Unscrew the lens and operate the camera on a slow shutter speed. Watch the movements of the mechanism.
3 Look through the unscrewed lens while pointing it at a window. Ask your teacher to show you the action of the iris diaphragm.

Basic film

Film is always supplied in a light-tight container. It has to be kept in total darkness because film reacts to light. Something that reacts to or changes in light is called **photo-sensitive.** Many things change with light. In sunlight, skin turns brown, green apples ripen and, as you have seen, printing paper darkens.

In photography, certain types of photo-sensitive chemicals are used. These are the salts formed when silver reacts with chemicals from the halogen group (iodine, chlorine and bromine). They are called **silver halides.** The main silver halide used in photography is **silver bromide.**

Photographic film is covered in a thin coat of tiny, flat, triangular silver bromide crystals. They are scattered in a binding glue called **gelatin.** This thin photo-sensitive coating is called the **emulsion.** It is the ability of the crystals in the emulsion to change when exposed to light that is the basis of photography.

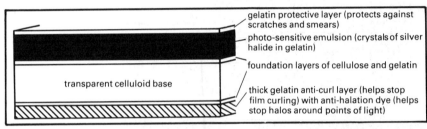

gelatin protective layer (protects against scratches and smears)

photo-sensitive emulsion (crystals of silver halide in gelatin)

foundation layers of cellulose and gelatin

transparent celluloid base

thick gelatin anti-curl layer (helps stop film curling) with anti-halation dye (helps stop halos around points of light)

Cross-section through a black and white film

The emulsion of a black and white film is **panchromatic,** which means that it is sensitive to all colours. In a colour film there are three separate emulsions sandwiched together. They are sensitive to blue, green and red light, in turn.

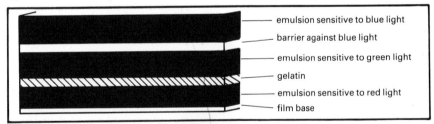

emulsion sensitive to blue light

barrier against blue light

emulsion sensitive to green light

gelatin

emulsion sensitive to red light

film base

Cross-section through a colour film

When light falls on a photographic emulsion, specks of metallic silver are formed on the silver bromide crystals that have been struck by the light rays. These silver specks form a permanent but invisible image. This is called a **latent image.** The image is made visible by development in chemicals. The resulting image on the film is called a negative. When silver bromide crystals are grouped together, they are known as **grains.** One square centimetre of emulsion contains many millions of grains. These grains can vary in size, depending on the type of film.

Bigger grains are easier targets for light rays to hit. This means that a film with bigger grains is more sensitive to light (will react more quickly) than a film with smaller grains. This differing photo-sensitivity of film emulsions is called film **speed** and is measured in **ASA numbers.** The higher the number, the faster and more sensitive to light is the film.

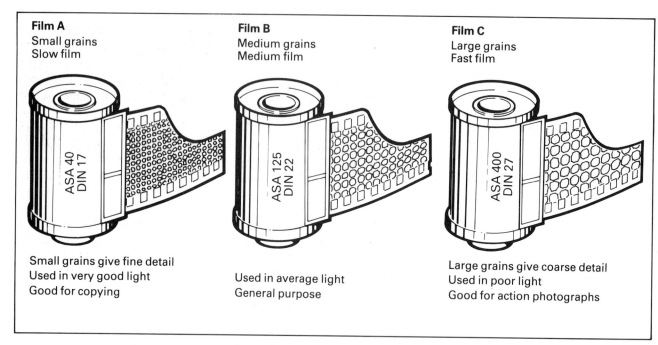

Film A
Small grains
Slow film

ASA 40
DIN 17

Small grains give fine detail
Used in very good light
Good for copying

Film B
Medium grains
Medium film

ASA 125
DIN 22

Used in average light
General purpose

Film C
Large grains
Fast film

ASA 400
DIN 27

Large grains give coarse detail
Used in poor light
Good for action photographs

Practical things to do . . . loading and unloading the camera

Study your camera's instruction book carefully. Correct loading of the film is essential. There are differences in the way you load a 35 mm camera, according to which make of camera you have. Always load and unload your camera in the shade, being careful not to touch the shutter or the pressure plate.

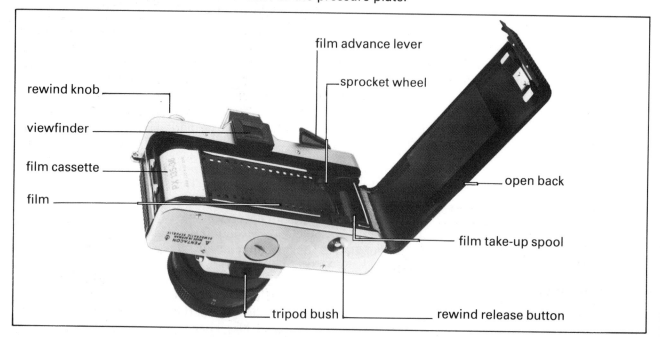

film advance lever

sprocket wheel

rewind knob

viewfinder

film cassette

film

open back

film take-up spool

tripod bush

rewind release button

Open the back of the camera. The film cassette fits into the left-hand compartment as shown in the photograph.

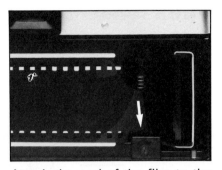

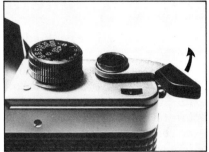

Attach the end of the film to the right-hand spool, making sure that the holes fit on to the sprocket pins on the spool. Wind on the film with the back open to see that everything is working smoothly. Rewind any slack film into the cassette.

Shut the camera back. With the lens cap on, press the shutter release button. Wind on two frames, making sure that the rewind knob is going round. If it is not, open the camera back *in complete darkness* and start again. You can improvise a changing bag with a coat.

If everything seems to be working properly, check that the exposure counter is pointing to 'one'. If it has not reached 'one', wind on more frames until it does. If it is beyond 'one', do not worry.

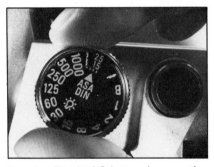

Set the film's ASA number on the shutter speed dial. Set the aperture and shutter speed for likely conditions, and the focus at 5–7 m. Then you will be able to photograph unexpected events without worrying about the settings.

When you need to unload the film, press the rewind release button on the bottom of the camera. This frees the wind-on mechanism so you can wind the exposed film back into its cassette.

Flip up the lever on the rewind knob. Use it to turn the knob clockwise and keep turning until it feels loose and spins freely. If you are not sure whether this has happened, do not open the camera back except in complete darkness.

Improvising a changing bag with a coat

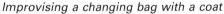

Film and camera types

Small formats

Small size films, in easy loading cartridges, are suitable for snaps. Used in compact cameras. Simpler versions have a fixed focus lens. Some types have variable aperture control, usually with a fixed shutter speed. Advanced versions can be semi-or fully automatic.

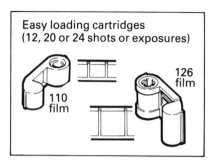

Easy loading cartridges
(12, 20 or 24 shots or exposures)

110 film

126 film

110 'pocket' camera

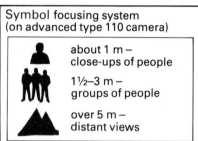

Symbol focusing system
(on advanced type 110 camera)

about 1 m –
close-ups of people

1½–3 m –
groups of people

over 5 m –
distant views

In 'instamatic' cameras, a direct viewing viewfinder at the top gives a good guide of what will be photographed. The viewfinder is misleading when taking close-ups. Because of this, and because their lenses are not interchangeable, these cameras are not very versatile.

126 'Instamatic' camera

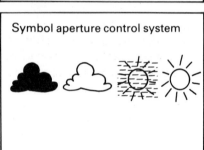

Symbol aperture control system

Standard negative size making good enlargements. The camera below has shutter in non-interchangeable lens. This light and compact camera is ideal for informal shots.

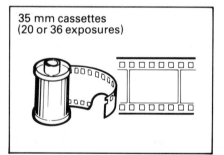

35 mm cassettes
(20 or 36 exposures)

The simplest 35 mm camera has a direct viewing system. More advanced types have a focusing system coupled with a **rangefinder** device. This helps you to measure the distance of the subject. Two images are present: one from the viewfinder and one from the rangefinder. By turning the focusing ring, the two images are brought together in focus.

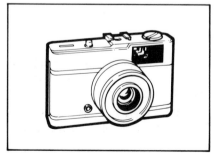

A type of camera which takes *and* develops the picture within the camera body. Useful for snaps, but with high film cost. Polaroid 'backs' are frequently used by professional photographers on 2¼ in SLR and monorail cameras for test shots.

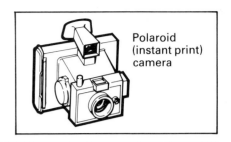

Polaroid (instant print) camera

Larger formats

Larger negative size capable of making excellent enlargements. This camera has a focal plane shutter and reflex viewing system (as in 35 mm SLR cameras) with interchangeable lenses.

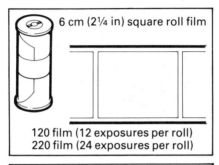

6 cm (2¼ in) square roll film

120 film (12 exposures per roll)
220 film (24 exposures per roll)

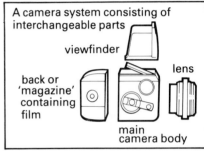

A camera system consisting of interchangeable parts

viewfinder

lens

back or 'magazine' containing film

main camera body

It is more bulky than a 35 mm SLR. Improved picture quality together with the advantages of reflex viewing and interchangeable lenses make it a favourite camera with professional photographers. Expensive. Some versions have pentaprism giving normal image; others are viewed at waist level giving a mirror image.

Same negative size. Wide range of prices and features. Good portrait and landscape camera. Waist level viewfinder makes it unsuitable for action photography.

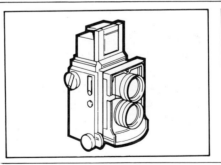

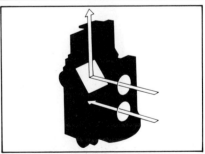

Twin lens reflex cameras have two lenses: the upper lens projects image onto a fixed mirror which reflects it into the viewfinder (mirror image same size as negative image); the bottom lens is the picture taking lens. Available in fixed focus or focusing versions with either non-interchangeable or interchangeable lenses. Shutter is in the lens.

A direct view camera using cut sheet film up to 25.4 cm by 20.3 cm (10 in × 8 in). Restricted use on tripod. Normally used in studios. Very expensive professional camera.

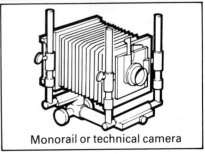

Monorail or technical camera

Holding your camera

When holding a camera to take a picture, you must hold it steady. Failing to do this will result in **camera shake**, and this will make your pictures blurred. To avoid this common fault, correct holding of the camera is vital.

1 Press the shutter release *gently.*
2 Always be careful not to put your fingers or the camera case in front of the lens.
3 Support the camera under the lens with your left hand.
4 Keep your elbows to your side.
5 Always stand with your legs well apart.

Always hold the camera against your face – either horizontally or vertically

 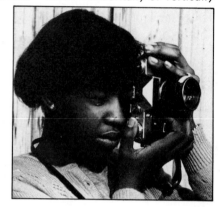

Body positions and the camera

squatting

kneeling

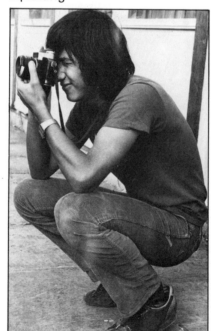 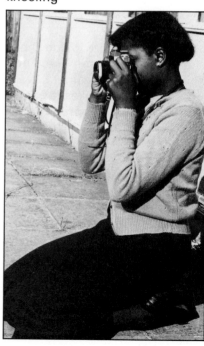

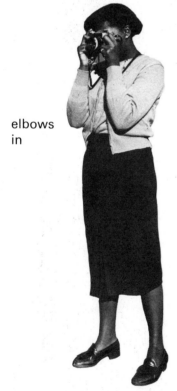

elbows
in

Relax

Always stand with legs well apart

Resting the camera (for extra support)

use cloth as cushion against hard surface

lying on floor

resting on chair back

The ideal support for a camera is a tripod.

crouching

feet apart

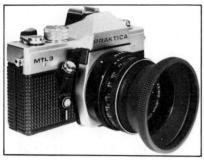

Lens hood to shield the lens from flare

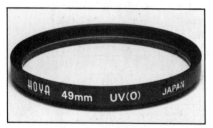

Ultra-violet filter

A puffer brush like this is perfect for blowing and brushing dust from the lens or inside the camera

Camera accessories

At shutter speeds of 1/30 s or slower, it is best to use a **tripod** to hold the camera steady. This is a three-legged stand on to which you can screw the camera body. The tripod can be adjusted to raise or lower the height of the camera. You can also tilt the camera in any direction.

A **cable release** should also be used, to avoid shaking the camera at slow shutter speeds. This allows you to take a picture without touching the camera. The cable screws into the shutter release button at one end and you press the button at the other. Cable releases come in different lengths. Many 35 mm SLR cameras have a delayed action release lever. This allows the photographer to include himself in the picture; it can also act as an alternative to a cable release.

A **lens hood** is a tube which you screw on to the front of the lens. It can shield the lens from unwanted light (flare) which would spoil the picture; for instance, when you take a photograph looking towards the sun. It is also useful for protecting the lens against knocks.

You can buy a special clear disc of glass called an **ultra-violet filter**. This is an inexpensive accessory that is screwed on the front of the lens and left permanently in place. It will protect the lens and help keep it clean.

The four pieces of equipment mentioned above as accessories are essential pieces of equipment, to help you take better pictures. If you have studied and practised all the points in this chapter you will be able to load your camera ready to take your first pictures.

Practical thing to do . . .

Make a checklist on a piece of card, that you can carry with you, of points to remember before you take a picture.

Camera care

1 Become familiar with the parts of your camera and use them correctly.
2 A camera is a delicate precision instrument. Never attempt to repair it yourself.
3 Always keep the camera in its case with the lens cap on. If you don't have these, buy them.
4 Always keep your hands clean; keep your camera clean, especially the lens. If the lens of your camera gets scratched, greasy or dirty, it will spoil your photographs. *Never* use a handkerchief or a tie to clean the lens. If you change the lens, do not get dust on it or in the camera.
5 Keep the camera away from dirt, sand, heat and water.
6 Watch out, there's a thief about!
7 Carry your camera with the straps around your neck, not over your shoulder.

Exposure table

8 Protect your camera from knocks and vibrations.

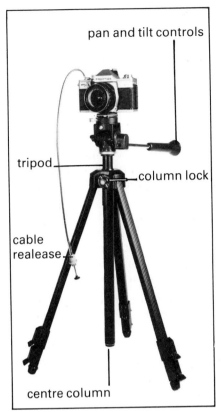

pan and tilt controls

tripod

column lock

cable realease

centre column

Tripod

What have you learnt so far?

1 What is the meaning of these terms: focal plane, focal point, focal length? Draw a diagram to explain your answer.
2 Give short definitions of the following terms: aberrations, lens barrel, standard lens, inverted, focusing.
3 What is the difference between a compound lens and a simple lens? Draw a diagram to explain your answer.
4 List the basic parts of a simple camera.
5 In what important ways does an SLR camera differ from a simple (basic) camera?
6 What is the purpose of (a) a shutter and (b) an iris diaphragm? How do they control the amount of light entering a camera?
7 What do these words mean: reflex, pentaprism, aperture?
8 *a* Complete the following sentence.
 A _____ f number gives a large aperture. A _____ f number gives a _____ aperture.
 b Complete the following series of aperture (f) numbers.
 _____ 11 _____ _____ 4 _____ _____
9 Complete the following sequence of shutter speeds.
 1000 _____ _____ 125 _____ _____ 15
10 Delete the wrong words in the following sentences.
 a A fast shutter speed lets in *more/less* light than a slow shutter speed.
 b A shutter speed of 1/30 s lets in *half/twice* as much light as 1/60 s.
11 What do these words mean: fogging, infinity? (What symbol is used for infinity?).
12 Make a list of things that change with the effect of light.
13 What is the main silver halide used in photography?
14 What does a photographic emulsion consist of?
15 Complete the following sentence.
 Silver bromide crystals form a _____ image when exposed to light; this is made visible by _____ to form a _____.
17 Delete the wrong words in the following sentence.
 The higher the ASA number, the *faster/slower* and *more/less* sensitive to light is the film.
18 What do these words mean: photo-sensitive, panchromatic?
19 What speeds of film are best (a) for taking pictures in poor light, (b) when copying a document and (c) for action photography?
20 What is the difference between an in-lens shutter and a focal plane shutter? What are the advantages and disadvantages of both?

More practical things to do . . .

1 Improvise a changing bag with a coat. Practise opening the camera inside it, and loading and rewinding a film.
2 Find out the actual negative size in millimetres of each of the film types. Draw all of these types to scale on one piece of graph paper.
3 Decide which features you think are most desirable in a camera. If you could choose any *one* feature, which would it be and why?

Chapter 3

Exposure

Exposing your first roll of black and white film

Probably the most confusing controls on a camera are the ones that control the amount of light the film receives (the exposure). If too much light falls on to the film, then the final photographic print will be pale and **overexposed**. If too little light falls on to the film, the final picture will be too dark and **underexposed**.

The amount of light reaching the film is controlled by the shutter speed and the aperture. When exactly the right amount of light reaches the film, it is said to be correctly exposed. **Correct exposure** will give a final print that looks true to life because it has a full range of grey tones from dark to light. An outdoor scene in sunshine will need less exposure (smaller aperture or faster shutter speed) than the same scene on a dull day with poor light (larger aperture or slower shutter speed).

For every light condition there will be a number of combinations of shutter speed and aperture that will give the correct exposure. This chapter shows you how to find the right combination.

Shutter speeds are measured in fractions of a second. Each number lets in *twice* as much light to the film as the following one; *half* as much as the previous one. For example, 1/250 s lets in twice as much as 1/500 s and half as much as 1/125 s.

The aperture controls the amount of light reaching the film. The **f numbers** (also known as stops) form a precise series of numbers, even if they do look confusing. As the numbers get bigger, each stop lets in *half* as much light as the previous one; *twice* as much as the following one. For example, f 8 lets in twice as much as f 11 and half as much as f 5.6.

A stop is the change in exposure between one f number and the next. On a dull day we would **open up** the aperture to let in more light. On a sunny day we would **stop down** the aperture to reduce the amount of light falling on the film. How do we decide what combination of aperture and shutter speed to use?

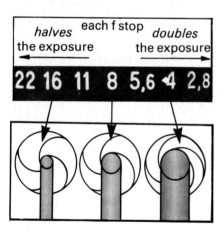

each new shutter speed

halves the exposure

doubles the exposure

halves the exposure each f stop *doubles* the exposure

22 16 11 8 5,6 4 2,8

Exposure table

Weather symbol	Weather	Camera settings (125 ASA film)
☀	Bright or hazy sun (distinct shadows)	f 16 1/125 s
☀	Weak hazy sun (soft shadows)	f 11 1/125 s
☁	Cloudy bright (no shadows)	f 8 1/125 s
☁	Cloudy dull or open shade (no shadows)	f 5.6 1/125 s

Using a film chart for correct exposure

With each film you buy, an **exposure table** of suggested settings is included. With your first roll of film, use the film chart to get the correct exposure.

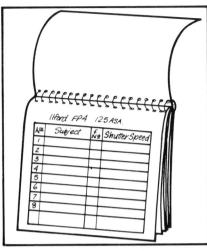

A log is a careful note of the settings used for each photograph

Practical thing to do . . . using 125 ASA film

On your first roll of film, try the following experiment.

Choose the correct set of camera settings, depending on the weather. Take a picture of a still object or view (a house or group of trees, for instance). Keeping the same subject in the viewfinder, take three other photographs. These should be exposed at the remaining three pairs of numbers shown in the chart.

Starting with your first film, always keep a **log** of the subject, aperture and shutter speed. This will avoid wasting film in the future.

Develop the film (see Chapter 4). Make a set of small prints (see Chapter 5). Give each negative the same exposure time in the enlarger. (This exposure time should be based on the first of the four negatives.) Mount the four photographs on card. Write the aperture and shutter speed against each photograph.

Positive

Negative

Examine your mounted photographs and compare them with the negatives from which they were made. You should see that:
1 the parts that are light in the subject and the print are dark in the negative
2 the parts that are dark in the subject and the print are light in the negative
3 while the overexposed print looks too light, the negative from which it was made looks too dark

4 while the underexposed negative looks too light, the print which was made from it looks too dark. This is because the dark parts of the negative hold back the light from the enlarger lamp.

If you look at the four photographs, you will see that the subject can still be seen, even in the incorrectly exposed ones. This is due to **exposure latitude**, which is the ability of a film's emulsion to cope with incorrect exposure. Black and white negative films can cope with a wrong exposure of up to two stops either way. Colour reversal (slide) films have far less exposure latitude: only one-third of a stop.

As you can see, an exposure table is only a rough guide. It will give acceptable results in average lighting conditions. It cannot cope with unusual lighting conditions (indoors, for instance). In these conditions it would be useful if we could measure the strength of light exactly.

Measuring the strength of light, using exposure meters

An **exposure meter** measures the strength of light and gives it a number on a scale. From this number, we can choose a more precise pair of exposure settings.

Hand-held exposure meters

A hand-held exposure meter contains a light-sensitive **selenium cell**. Light falls on to the cell and generates an electric current. The strength of this current depends on the brightness of the light. The current moves a needle across a light reading scale and gives a number value to the strength of light. A screen (or baffle) flips up over the cell so that it can be used in both strong and weak lighting conditions with two different scales for the needle.

Study the instruction booklet for the exposure meter carefully. It is a delicate precision instrument – treat it with great care.

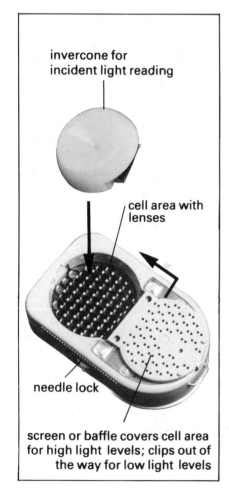

invercone for incident light reading

cell area with lenses

needle lock

screen or baffle covers cell area for high light levels; clips out of the way for low light levels

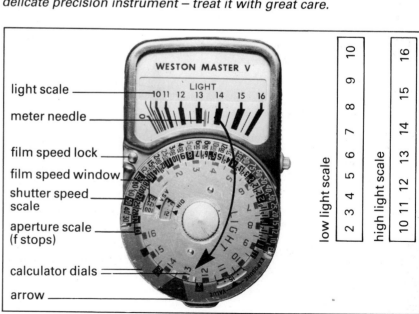

light scale

meter needle

film speed lock

film speed window

shutter speed scale

aperture scale (f stops)

calculator dials

arrow

low light scale

high light scale

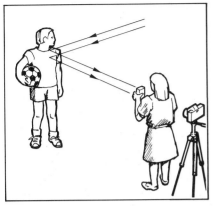

Taking a reading of reflected light

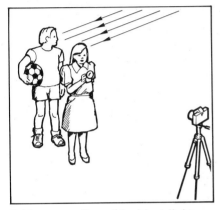

Taking a reading of incident light

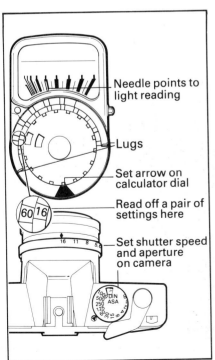

Needle points to light reading

Lugs

Set arrow on calculator dial

Read off a pair of settings here

Set shutter speed and aperture on camera

There are two methods of taking a light meter reading using a hand-held exposure meter.

Reflected light method

1 Standing at the camera position, hold the meter upright and point it at the subject.
2 Press the needle lock button and make a note of the number the needle points to.
3 Be careful not to cover the cell with your fingers.
 This method may lead to underexposure if strong light from behind the subject (back light) is allowed to mislead the meter. Overexposure might occur if the subject is surrounded by a large dark area.

Incident light method

With this method, you measure the light falling on (**incident** on) the subject.
1 Place the **invercone** in position.
2 Stand at the subject position and point the invercone (meter upright) towards the camera lens.
3 Press the needle lock button and make a note of the number the needle points to.
4 Be careful not to cover the invercone with your fingers.
 Out of doors it may be impossible to stand by the subject. In that case, take a reading where the light falling on to the meter is the same as that falling on to the subject. Remember to point the invercone towards the camera.
 A reflected light reading measures the average brightness of a scene such as a landscape. It is a good guide to exposure where an incident reading is difficult to take.
 An incident light reading with the invercone is more accurate, because it takes side, back and front lighting into account. The invercone is usually held at the brightest part of the subject. This method is ideal for portraits, both indoors and out.
 In difficult lighting conditions you can take both types of reading, or an incident reading at the darkest *and* brightest positions, and compare the settings given.

Working out the exposure

1 The speed of your film should appear in the film speed window. Press the film speed lock button to move the window to the correct number.
2 Move the arrow by turning the dial with the lugs until it points to the reading you took on the light scale.
3 Any shutter speed and aperture now opposite each other on the calculator dial will give you the correct exposure.

1/sec	f no
1000	4
500	5.6
250	8
125	11
60	16
30	22
15	32

Practical things to do . . . using 125 ASA film

1 Leave the arrow pointing to the same light value number. Turn the window to 50 ASA and then to 400 ASA, while keeping the film speed lock button depressed. How does this affect the exposure settings?

2 Choose a still object or a view. Take a reflected light reading and work out the corresponding apertures for shutter speeds 1/250 s, 1/125 s and 1/16 s. Take three photographs of the subject, using these settings.

Make a set of small prints, giving each negative the same exposure time in the enlarger (see Chapters 4 and 5). You will notice that all three photographs have exactly the same exposure. Write down the settings you used for each of them.

You should see that a larger aperture means using a faster shutter speed, while a smaller aperture means using a slower shutter speed. If the aperture is doubled in area (f number *down* one stop), the shutter speed must be halved (the next highest shutter speed number).

Each pair of aperture and shutter speed settings lets in the right amount of light to give a correct exposure. As the calculator dial shows, we have a wide variety of pairs of settings to choose from.

apertures (f stops)

shutter speeds

Built-in exposure meters

The simplest built-in exposure meter usually has a light-sensitive cell on the outside of the camera body. It points at the subject from a position near the camera lens, and works in the same way as a hand-held meter.

35 mm SLR cameras are more likely to have a **cadmium sulphide** (or the newer, faster reacting, **silicon**) photoelectric cell situated *inside* the camera. These cells rely on a battery to operate them. It is important to check the state of the battery regularly.

This type of meter measures the light that passes Through The Lens (hence the abbreviation, **TTL metering**). It is one of the best methods of metering because it is accurate, quick and compensates automatically for camera accessories (such as filters) that reduce the amount of light entering the lens.

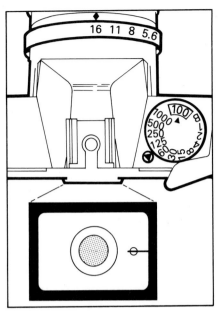

The match needle method

Using a built-in TTL meter

Many TTL meters are linked to both the aperture and shutter speed controls. You change the aperture and shutter speed by hand (non-automatic manual system) until the meter shows that you have a combination that will give correct exposure. This is called the match needle method.

The following general steps are for an average weighted TTL meter. *Study your camera instruction book carefully.*

1. Check that the correct film speed appears on the shutter speed dial.
2. Select a shutter speed.
3. *a* Switch on the metering system. This is done by pressing down the shutter release button half way or by pressing a separate exposure meter button.
 b Look through the viewfinder.
4. Turn the aperture ring.
5. The exposure meter needle will move up and down. When the needle is inside the circle you have a combination that will give correct exposure. If you cannot get the needle up into the circle (too little light), change to a slower shutter speed. If you cannot get the needle down (too much light), change to a faster speed.
6. If you prefer, you can select your f stop number first and then adjust the shutter speed dial until the exposure meter needle shows correct exposure.

Semi- and fully-automatic cameras

It is becoming more common for cameras to have semi- or fully-automatic metering systems.

One type of semi-automatic camera uses a **shutter priority** (or shutter preferred) system. You select the shutter speed you want, and the camera automatically sets the correct aperture.

In the **aperture priority** (or aperture preferred) system, you set the aperture, and the electronic shutter automatically adjusts to the correct speed.

On some models of camera you can switch from shutter to aperture priority. Some fully-automatic cameras set a balanced combination of aperture and shutter speed completely by themselves. The information is displayed in the viewfinder.

All metering systems need intelligent understanding to produce accurate exposure readings. In certain unusual lighting conditions your meter can be 'fooled' and give incorrect exposure. This is because even a fully-automatic camera is still only a 'non-thinking tool'. In such conditons you can decide the aperture and shutter speed yourself: you 'over-ride' the meter.

TTL meters vary, according to which part of the picture area they are taking readings from. This is called the **weighting** of the meter. They do this by being placed at different positions within the camera body.

Average reading

Two cells give an average for the whole area. Can be misled by large dark or light areas.

Spot reading

Very precise and harder to use. With a wide range of tones it might read from the wrong one. Look for a mid-tone to read from. The back of your hand can be used as a substitute.

Centre weighted

Easy to use, measuring mainly from the bottom of the central area. Be careful when holding the camera vertically.

Position of photo-electric cells ●

It is important to know which system your camera uses. Each system has its disadvantages. It is a good idea to take your reading with the camera held horizontally before you take a vertical shot. A centre weighted meter could be misled, as shown in the picture.

Difficult lighting situations

The three lighting situations shown are typical of the conditions that could mislead your light meter. There is a big difference (**contrast**) in light value between the very light areas (**highlights**) and the very dark areas (**shadows**).

The human eye can cope with contrasting lighting conditions. Your light meter cannot cope with such big contrasts.

Practical things to do . . .

1 Find three lighting situations similar to the following:
 a an enclosed dark area leading into a brightly-lit area
 b a figure or object strongly lit from behind (back lighting)
 c a small main subject, surrounded by a large area of contrasting tone.
 For each situation, use a hand-held meter or spot (centre) weighted TTL meter.

2 Take three pictures using the same shutter speed in each, with the following light meter readings:

a taken from close to the highlight area to expose for highlight detail, thus losing shadow detail

b taken from close to the shadow area to expose for the details in the shadow, thus losing highlight detail

c an aperture setting half-way between **a** and **b**, to achieve a compromise between the two.

Make a set of small prints. Give each negative the same exposure time in the enlarger (see Chapter 5). For each lighting situation, the three photographs you have taken will probably look something like the set shown here.

'Correct' exposures for highlights

'Correct' exposure for shadows

A compromise between the two

All three pictures have been 'correctly' exposed according to the meter but they look very different. In the future, you will have to decide which 'correct' exposure you are aiming for.

When you are making adjustments to cope with difficult lighting conditions, you are **compensating** for them in order to achieve correct exposure.

Bracketing

When you are in doubt about the correct exposure for a particular situation, it is always better to overexpose the picture rather than underexpose it. This will at least ensure that as much detail as possible will be recorded on the film's emulsion.

In difficult situations you can take several pictures. Using black and white film, set a difference in exposure of one stop up and down for each photograph you take. (A half stop when using colour film.) This is called **bracketing** the exposure. For instance, if your indicated setting is f 8, take a shot at this aperture. Then one shot at one stop over (f 5.6) and another at one stop under (f 11).

Summary

To obtain a correct exposure you must know three things:

1 the speed of your film (its sensitivity to light)
2 the way that the shutter and aperture work together to control light reaching the film
3 how to assess correctly the strength of light (how to take a light reading).

What have you learnt so far?

1 Fill in the missing words in the following sentences.
 a An overexposed negative looks _____ even though the print looks pale.
 b An underexposed print looks _____ and is made by a _____ negative.

2 Delete the wrong words in the following sentences.
 a Opening the aperture by one stop *doubles/halves* the amount of light reaching the film.
 b Changing the shutter speed from 1/30 s to 1/60 s *doubles/halves* the amount of light reaching the film.

3 a Copy and complete the table below. Use a light meter to work out the correct combinations.

Shutter	Aperture					
250	8			60		Very bright light
		125	8			Normal light
250				60	8	Poor light

 b What do you notice from the finished table?

4 Fill in the missing words in the following sentences.
 The faster the shutter speed, the _____ the aperture.
 The _____ the shutter speed, the smaller the aperture.

5 What does exposure latitude mean?

6 How does a light meter work? What is the flip-over baffle or screen used for? What is the invercone used for?

7 What do you think are the advantages and disadvantages of a hand-held meter?

8 When taking a reflected light reading, how would you compensate for (a) a large area of bright sky and (b) a strong light source behind the subject?

9 How would you take an incident light reading?

10 What are the advantages and disadvantages of TTL metering? What type of weighting would give the most accurate exposure in a strong back light situation?

11 When and how would you over-ride the metering system in (a) a semi-automatic and (b) a fully automatic camera?

12 By changing the ASA number on a metering system (*and then remembering to change it back*) you can compensate for difficult lighting situations. Using 125 ASA film, what ASA number on the camera would you set to compensate for (a) a back-lit subject and (b) a very bright subject to one side of the viewfinder?

13 How would you ensure correct exposure for an important picture when using only the film chart?

subject

latent image

developed image

fix and wash

negative image

final photographic print

Development

There are many advantages in doing your own developing.

1 Other people are unlikely to take as much care of your film as you will.
2 Developing your own film is cheaper and quicker and you can see the results on the same day.
3 You can choose the developer that best suits your purpose.
4 The end result is completely within your control.
5 It is exciting to examine your negatives after processing them.

Processing your film

When a photograph is taken in a camera the film's emulsion is exposed to light. When a light ray strikes a silver bromide grain, a tiny speck of black metallic silver is formed. These specks form the weak undeveloped image (the **latent** image).

The **developer** makes this tiny speck of silver much bigger so that the whole grain is turned to black metallic silver. If you could see inside the tank, you would see the developer making the image strong and visible. The action of the developer is a magnification (amplification) process. The grains which have not been exposed to light will stay undeveloped and will not turn black.

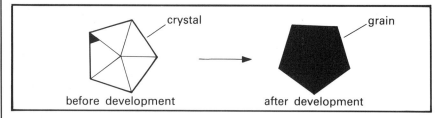

before development after development

If we were to look at our film after developing it, the light would fog the whole image, turning it black. We need to 'fix' the image on the film. To make it permanent it is necessary to dissolve the remaining unexposed and undeveloped grains in a chemical solution known as a **fixer**. The fixer also contains a **hardener**, which toughens the film.

Even though the image has been made permanent, it is still necessary to *wash* the film thoroughly. Washing the film does two things:

1 it removes the grains made soluble by the fixer.
2 it removes the fixer itself (which would stain the film if left on).

The fixed, visible image is called a 'negative'. The tones are reversed so that the bright part of the subject become dark and the dark parts become light.

The developer and fixer do opposite chemical jobs. If developer is mixed with the fixer, the fixer will work less efficiently. To stop this happening the film is placed in a '**stop bath**' (a solution of acetic acid) after it has been developed. As well as protecting the fixer, it stops further development.

In order to develop your film, it must first be placed into a light-tight **developing tank**. You can load your film in a darkroom, a changing bag, a wardrobe or under the bedclothes at night. The important thing is that *no light at all* reaches the film at this stage, otherwise it will be fogged. After loading, all other processing stages can be done in the light.

Developing tank

In the 'Universal' developing tank, the spiral can be adjusted to different film sizes. The cap should be a water-tight fit on the lid to prevent liquid escaping during **agitation**. Chemicals can be poured into and out of the tank when the cap is removed. When the lid is screwed on, the funnel fits inside the centre column, forming a light trap.

The agitator is used to turn the spiral. The spring collar stops the spiral slipping up and down the central column. The two parts of the spiral are grooved to hold the coils of the film apart. This enables full overall development. It can be adjusted to different film sizes. The spiral is held in the central column. This hollow plastic tube forms a light trap with the funnel. The chemicals enter the tank through the central column and rise up from the bottom.

The tank body is made of brittle plastic. If dropped it can crack and become useless. Never leave a tank near the edge of a bench.

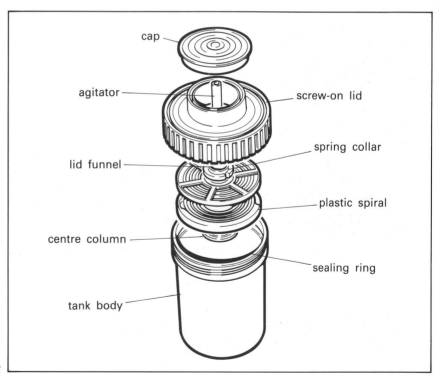

Developing tank

Learn how all the parts of your developing tank fit together. Practice taking the tank apart and re-assembling it in total darkness or with your eyes closed.

Loading a film into a developing tank: a step-by-step guide

Always make sure that the tank parts are clean and dry. You will find it difficult to load a film into a spiral that is wet or even damp.

Practice the action of loading the film on to a spiral many times. Practice in the dark or with your eyes closed, using a spare length of film. If the film jams when loading the spiral, take it out and start again. If you are still unsuccessful, you can place all the film inside the tank, with the lid *and* cap on, and ask for assistance.

Loading the film must be done in total darkness.

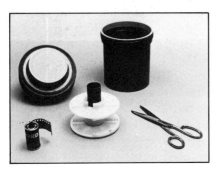

Lay out the parts in order of assembly. Ensure entry slots of the spiral are opposite each other. Keep a pair of scissors handy.

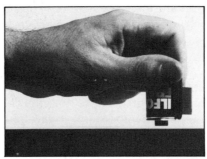

Press or bang down the cassette on to a hard flat surface. This will force off the top of the cassette.

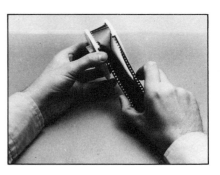

Remove the film. The first few centimetres can be gripped. After that, avoid touching the film except by its edges. Trim the film end square. Feed the film into the entry slots with the emulsion (rough side) down.

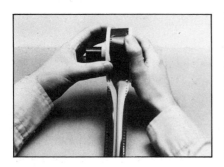

Turn the sides of the spiral alternately backwards and forwards. Use your thumbs on the edge of the film to alternately hold and feed the film into the spiral.

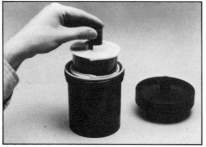

Cut off the spool. Replace the spiral and column back into tank body. Replace with the column pointing up.

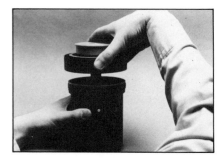

Carefully screw on the lid. Be careful not to cross the threads. *Once the lid is on all the remaining stages may be done in the light.*

Before developing a film

It is important to make sure that you have all the pieces of equipment you will need before you start developing a film. You will need working solutions of three chemicals: developer, stop bath and fixer. You can use the photograph opposite as a check list.

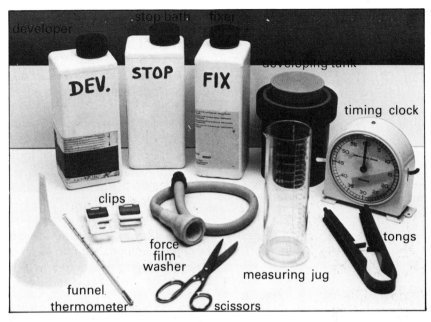

Developing equipment

Using a thermometer

The temperature of your working solutions is important, particularly the developer. Make sure you read your thermometer accurately, keeping its bulb in the liquid. Rinse the thermometer after use, and return it to its container.

General points

Developers and fixers may come in either liquid or powder form. Always follow the instructions *exactly* when dissolving and mixing chemicals.

A developer solution which can be topped up with a stronger solution and re-used is called **replenishable**. A developer which can only be used once and then must be discarded is called **one-shot**. Check that you know which type you are using.

The solutions you start with will be in a concentrated form (**stock solutions**). You will have to dilute them carefully to the correct strength before you put them in the tank. Always make sure that the quantity of chemical you pour into the tank is enough to cover your film(s). Label all bottles with the type of chemical, date of preparation, and whether they are concentrated or at **working strength**. Make sure all container tops are fully tightened.

Working method

Keep all your equipment clean. Always rinse the thermometer, measuring glasses, funnels and bottles, as well as the tank parts, after they have come into contact with a chemical. If you spill chemicals, wipe them up. Be exact when measuring quantities, temperature and time.

Always be aware of safety when using and storing chemicals.

Four important points about the development stage

Assuming that the negative has been correctly exposed, four things will affect the amount of development the emulsion will receive.

1 The **time** of the development. This must be exactly as instructed. Too long a time results in overdevelopment; too short in underdevelopment.

2 The **temperature** of the developer. This must be exactly as instructed; usually 20 °C (68 °F). Too high a temperature gives overdeveloped negatives; too low gives underdeveloped negatives.

3 The **dilution** of the developer. This must be exactly as instructed. Too strong a solution results in overdevelopment; too weak in underdevelopment.

4 The amount of **agitation** (shaking or swirling of the solution). This must be exactly as instructed for the developer. Too much results in overdeveloped negatives; too little in underdeveloped negatives.

Overdeveloped negatives will look too black and dense. Underdeveloped negatives will look too pale and thin.

The development process: a step-by-step guide

The exact times and strengths of working solutions will vary according to the film, developer and fixer you are using. Guidance is provided with the materials. The development process consists of:

1 Develop 2 Stop 3 Fix 4 Wash 5 Dry

Here is a general step-by-step guide.

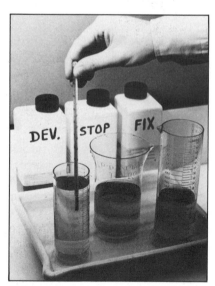

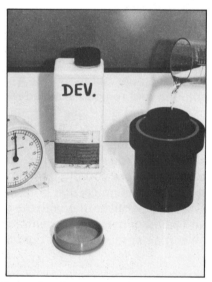

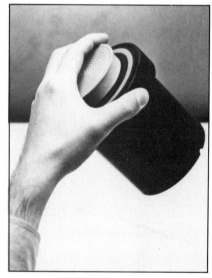

Bring or mix the developer solution to the correct temperature (20 °C/68 °F). The temperature for the stop and fix is not so critical. You can stand them in warm water to maintain them at the correct temperature.

Pour in the correct amount of developer quickly. Start timing immediately. Tap the base of the tank to get rid of any air bubbles.

Throughout the development time, agitate the tank according to the developer instructions. Keep a close check on the minutes as they pass.

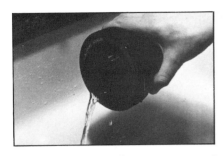

Five seconds before the end of development time, pour the developer away quickly (or return it to its container if it is re-usable).

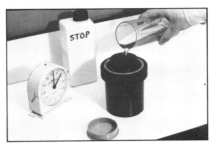

Pour in the stop bath or wash for one minute. Return the stop bath to its container.

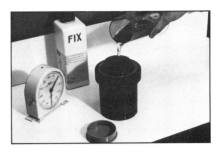

Pour in the fixer. Start timing immediately. Agitate at least once a minute.

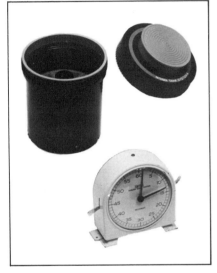

Do not take off the tank lid for at least three minutes. Fix for the full time indicated in the instructions. The film can be examined after this as it can no longer be fogged!

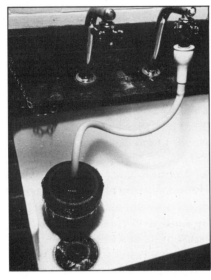

Return the fix to its container. Connect the centre column to a tap using a hose or force film washer. Allow the film to wash for 20–30 minutes.

After washing, add a few drops of wetting agent (concentrated soap solution) to the water in the tank. This will encourage even drying.

Agitate gently for a minute in the wetting agent. You can wipe the film with a clean pair of rubber tongs or your fingers.

Hang the film up to dry in a clean, cool, draught-free place. Use clips or pegs to hang the film from some string. To stop the film curling, attach another clip to the bottom of the film.

When the film is completely dry cut the film up into short lengths (usually sets of six pictures). Store them, preferably in negative filing sheets.

If you make a mistake when processing your film, you can make your negatives difficult or impossible to print. You must be accurate and totally consistent in your processing so that it becomes mechanical. Stick to the same procedure, so that you know the exact results you will achieve. When starting photography, avoid changing your film and developer combination. Find one that suits you and stick to it.

Useful hints

Processing a film can be made more efficient by:
1 using a **rapid fixer**, e.g. Amfix
2 using a **fixer eliminator**, thus reducing washing time, e.g. Thiolim
3 wiping the film down with rubber tongs to reduce drying time, or soaking in a preparation like 'Drysonal'
4 using a filter on the water supply, thus reducing the number of **drying marks** (marks left on the film due to uneven drying or contaminated water).

Negative care

Never touch the emulsion side of the film. Always hold negatives by the edges. Marks on the shiny side can be removed by gentle rubbing with cotton wool dipped in alcohol, or use of a film polish/cleaner.

Always store negatives in negative filing sheets away from heat and dirt. These sheets can be kept in a hard cover ring file. Each film should be filed with the corresponding contact sheet (see Chapter 5), and numbered. File the negative strips in the order that they are printed on the contact sheet. You could make an index at the front of the file with the list of numbers, a brief description of the film, and the log sheets.

More about photographic chemicals

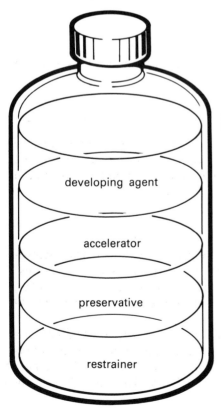

The main parts of a developer are:
1 The **developing agent**, which is a chemical reducing agent. Developing agents are very powerful. If measured by quantity, they form only a small part of the whole developer.
2 The **accelerator**, which makes the chemical solution 'alkaline'. It keeps the development time short because developing agents work best in alkaline solutions. An example is sodium borate ('borax').
3 The **preservative**, which is a chemical used to stop the developer 'going off' or oxidizing once it is mixed. It is also a reducing agent that affects the length of time that the developers can be stored. An example is sodium sulphite.
4 The **restrainer**, which is a chemical used to stop the developing agent converting silver bromide crystals which have not been exposed to light, to silver. An example is potassium bromide. Sometimes called an 'anti-foggant'.

Developer types

Type	Description	Example
Universal	MQ or PQ general purpose developers. Usually contains two developing agents. This type is suitable for either films (giving a 'grainy' result) or papers.	
Standard or fine grain	Suitable for leading brands of film. They have names and formulae that have been patented by the manufacturer.	D76, ID11
Ultra-fine or high acutance	These developers make the image look sharper by increasing the contrast at the boundaries between light and dark areas. They do not make the grains finer than they are.	Acutol
High contrast	For line or lith work. This type produces an image with no grey tones, only black and white. A 'contrasty' developing agent is used at high alkalinity. The solution has a very short shelf-life.	Kodalith

Fixers

Sodium thiosulphate or 'hypo' is traditionally the chemical used as the fixer.

Practical thing to do . . .

Put a short length of film into your newly-mixed fixer and note the time it takes to become completely transparent (the clearing time). When it takes double the original time to clear, the film remaining milky, the fixer is exhausted and should be discarded.

Intensifiers and reducers

An **intensifier** is a chemical solution which can make a weak negative image much stronger. It is used with an underexposed or underdeveloped image. It makes the black metallic silver look even blacker, often by converting it to mercury. It cannot add detail which is not present in the image.

 A **reducer** is a chemical solution which usually removes a layer of the black silver right across the whole image. It lightens a dense overexposed or overdeveloped image. It is, in fact, a chemical oxidizing agent. An example is potassium ferricyanide, which is usually bought as 'Farmer's Reducer'.

What have you learnt so far?

1 What are the main three stages in developing a film before washing and drying? Explain what happens to the film's emulsion at each stage.

2 Draw and label the basic equipment and chemicals required to develop a black and white film.

3 What are the functions of (a) a force film washer and (b) a wetting agent?

4 What is the difference between replenishable and one-shot developers?

5 Aiming for consistent results when developing your film, what four factors must you take into account?

6 Delete the wrong words in the following sentences.
 a Pale, thin negatives are caused by *underexposure/overexposure.*
 b Dark, dense negatives are caused by *underdevelopment/overdevelopment.*

7 Are the following statements true or false?
 a Fine grain films are normally developed in high contrast developers.
 b Both printing papers and films can be developed in a 'universal' developer.
 c Ultra-fine (high acutance) developers make an image appear sharper.
 d A line or lith film is not normally developed in a fine grain developer.

8 After fixing your film, it retained a milky appearance. What caused this?

9 After processing, your film has turned out (a) completely black, (b) completely transparent, (c) ends are black and the first frame is solid black, (d) the negatives look pale and thin. What are the likely reasons for these results?

10 What do the following terms mean: clearing the film, working strength?

11 What will happen to your film if you do not (a) develop it long enough, (b) fix it long enough, (c) wash it long enough?

12 What precautions should you take to obtain clean negatives, free of marks and dust?

Printing (making photographic prints)

Having developed your negatives, you will want to make prints from them. A commercial printing laboratory uses automatic machinery which cannot give your print the necessary individual attention. The advantages of making your own prints are:

1 It is cheaper and quicker than sending your film to a commercial laboratory.
2 You can have complete control over the final result, which can be creative and exciting.

It can be said that a snap is taken with a camera but a good photograph is created in the darkroom.

It is not necessary to have a darkroom to develop your films: they can be loaded into a tank in a changing bag or in a wardrobe at night. In order to produce prints from your negatives you must, however, have some form of darkroom.

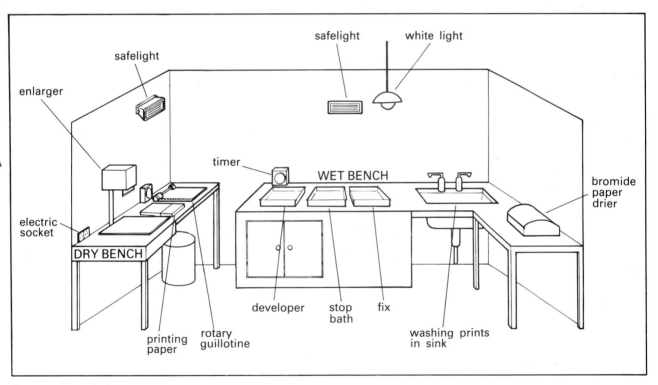

A permanent darkroom

The darkroom

A darkroom is a room or area in which all the sources of white light (windows, etc.) have been blocked or **'blacked out'**. It is essential that no light whatsoever can leak in as this would fog the light-sensitive printing paper. Although all the windows may have been blocked up, you must have a good enough air supply or **ventilation**, to allow you to work safely for long periods.

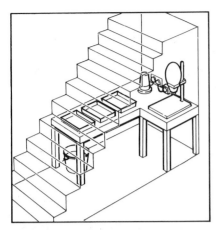

A small darkroom, with bucket to carry prints away for washing

A yellow, orange or red **safelight** allows you to see what you are doing but will not affect the emulsion of the printing paper. However, do keep safelights at least 1.5 m above places where paper will be handled, and do not let them shine directly on to printing paper.

A darkroom is always organised into **'wet'** and **'dry'** areas or benches. The 'dry' area contains the enlarger, printing paper and electric sockets. This is kept separate from the 'wet' area, which contains your processing chemicals. This division into two areas prevents spoiling printing paper with chemicals, keeps the electric socket safely away from liquids and prevents the corrosion of metal equipment.

A darkroom can be temporary or permanent. At home, you could set up a darkroom in the bathroom, the cupboard under the stairs, or in a bedroom. The room does not have to have running water but it must have an electricity supply.

In some big darkrooms there is enough room for you to wash and dry prints. If there is not enough space this can be done in another room in normal lighting.

The enlarger

The enlarger is the main piece of equipment in a darkroom and is like a camera in reverse. Light from an opal bulb is concentrated by a lens (**condenser**) into an even beam which passes through a negative. An image of the negative is focused and projected on to the baseboard by the **enlarging lens**. The action of an enlarger is similar to that of a slide projector, except that the bulb is very much weaker.

The quality of an enlarging lens is as important as the quality of a camera lens. Remember: a cheap enlarging lens will not do justice to the detail captured by your camera lens, especially when making large prints. Buy the best enlarging lens you can afford.

The enlarger should be as rigid as possible. A high column and large baseboard are useful. The head of an enlarger should not get too hot, because heat could distort your negative.

Enlarger types

In a reflex enlarger the negative is lit by the bulb via a mirror set at 45°. No direct heat falls on to the negative.

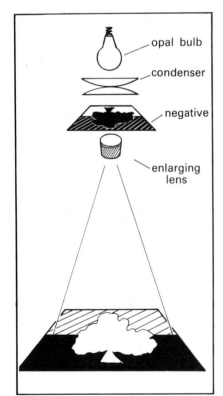

The essentials of an enlarger

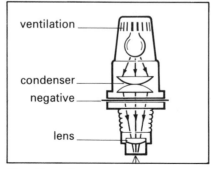

Direct lamphouse

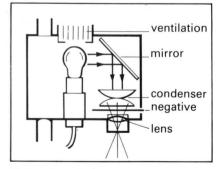

Reflex lamphouse

The enlarger and its parts

The column is rigidly attached to the baseboard. It is a rail upon which the enlarger can move up and down.

The lamphousing (either direct or reflex) contains a low power bulb. It gets warm and requires ventilation.

The condenser concentrates the light into an even beam.

The height adjustment control moves the whole enlarger up and down the column, altering the size of the image.

The negative carrier holds the negative flat, either by its edges or in between two glass plates.

The focusing knob moves the enlarging lens nearer to or further away from the negative. This alters the sharpness of the image on the baseboard.

The enlarging lenses are interchangeable. Different focal lengths are used for different negative sizes. (35 mm negatives require a standard lens of 50 mm focal length. 2¼ in negatives need a 75 mm lens.) The enlarging lens is similar to the camera lens, with a built-in iris diaphragm. The aperture of the lens can be varied to control the amount of light falling on to the paper.

The masking frame or enlarging easel holds the paper flat by its edges. This gives clean sharp edges to the final print and allows accurate measurement of its size. It can be adjusted to different paper sizes and gives white borders. After the enlarger, it is the most essential piece of equipment in the darkroom.

The amount of light or exposure the paper receives can be varied by the aperture of the lens and the time for which the bulb is switched on.

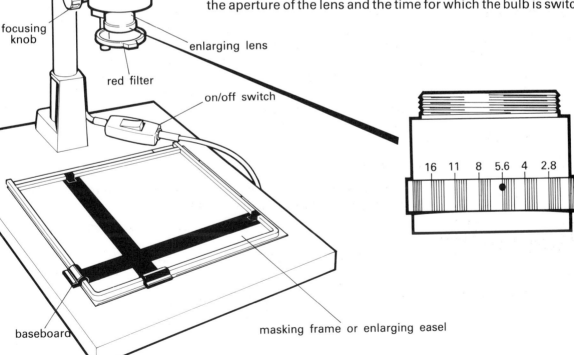

column

lamp housing

opal bulb

condenser

height adjustment

negative carrier

focusing knob

enlarging lens

red filter

on/off switch

16 11 8 5.6 4 2.8

baseboard

masking frame or enlarging easel

Enlarger accessories

An **electronic timer** can be wired into the enlarger's electricity supply. Electronic control of exposure times is convenient and more accurate than counting.

A **focus finder (magnifier)** can be used on the masking frame to magnify a small area of the image. It magnifies the grain structure, allowing you to focus more accurately.

Electronic timer

Focus finder

Enlarger care

If your negative carrier has two glass plates, keep them spotlessly clean. The condenser lens(es) must also be cleaned periodically, as the heat of the enlarger attracts dust. Treat the enlarging lens with the same care as a camera lens: never touch its surface. A dirty lens will affect the sharpness of your prints.

Always place a dust cover over the enlarger when it is not in use.

Printing papers

A cross-section through printing paper is very similar to the cross-section through a piece of film. A slow silver bromide emulsion consisting of small, light-sensitive grains is coated on to a paper base. The emulsion is protected by a supercoat, which can be used to give prints a glossy finish. This coating is increasingly being made of resin.

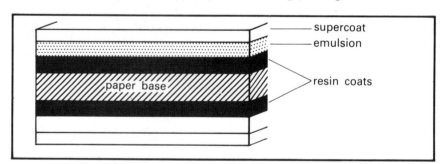

Cross-section through printing paper

Paper is sold in different **sizes**, either in packets of 10 or 25 sheets, or in boxes of 100 sheets. 12.7 cm × 8.9 cm (5 in × 3½ in) is a useful size to use, because its proportions match those of a 35 mm negative. 25.4 cm × 20.3 cm (10 × 8 in) is the size to use for contact prints.

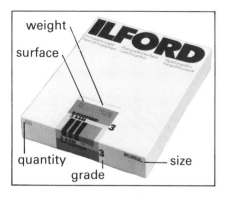

Paper is also sold in different thicknesses (or **weights**): single, medium or double weight. It also comes in different **surfaces**: matt, semi-matt (silk) or glossy, and in different **contrast grades** from 1 to 6.

When you choose and buy printing paper, it is important to know what size, grade, weight type and finish you want. This information is always written on the paper box.

Grades of paper

To help control the degree of contrast in your prints you can choose from a range of different grades and types of printing papers.

Paper is manufactured in six different contrast grades ranging from 1 to 6. You will find that the harder grades (higher numbers) need more exposure time. Do a test strip before printing a full sheet (see page 53). With experience you will be able to judge which grades to select from the contact sheet.

Grade	Contrast	Use
1	Soft	For negatives high in contrast
2	Normal	For normal negatives
3	Normal–hard	To give a slightly harder impact to a normal negative
4	Hard	For negatives low in contrast
5	Very hard	For very soft negatives
6	Not readily available	

Printed on grade 2 paper

Printed on grade 4 paper

How printing works

Printing exposure

If you place a sheet of printing paper on the masking frame, emulsion (shiny) side up, you can expose the enlarged negative image on to it. The amount of exposure the paper receives can be controlled by the number of seconds the enlarger bulb stays on *and* the aperture set on the lens.

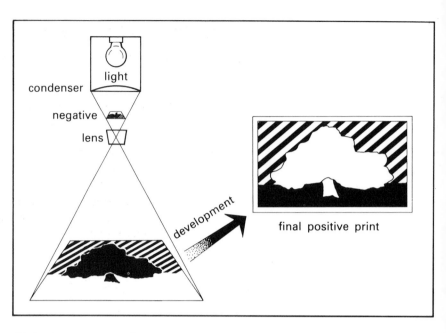

light

condenser

negative

lens

development

final positive print

Printing reversal

When you shine light through a negative, more light will reach the paper through the pale parts of the negative. On the developed paper these parts will be dark. Less light will reach the paper through the dark patches of negative and these parts will be light. This means that the tones of the negative will be reversed: the white parts of the negative will become black on the print, because this is where the photosensitive emulsion received most light.

DARKROOM RULES

1. Never enter or leave a darkroom without checking first that it will be safe to open the door.

2. Only take out one sheet of printing paper at a time. Always put the lid back on the box straight away.

3. Even the dim light from an enlarger can fog printing paper, so always turn it off when not in use.

4. Never touch electric switches with wet hands.

5. Always keep the darkroom clean and tidy.

Contact prints

Before making individual prints from your negatives you should make a **contact sheet**. This sheet consists of a set of positive prints the same size as the negatives.

Contact prints are made by laying your strips of negatives, emulsion side down, on a sheet of printing paper.

A 36 exposure film, cut into six lengths of six negatives each, can be placed on to a piece of 25.4 cm × 20.3 cm (10 × 8 in) paper. A sheet of heavy, well-cleaned, glass placed on top of the negatives will keep them flat and in contact with the paper. A **contact printer** is a more convenient and neater way of making a contact sheet, especially when negatives curl. Light from an enlarger (or light bulb) is shone through the negatives to form the positive images.

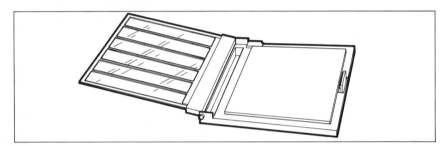

Contact printer

What are contact prints used for?

1 It is easier to 'read' a print than a negative. The best pictures can be marked with a chinagraph pencil.
2 A correctly exposed contact sheet can be a good guide, showing which of your negatives are over or underexposed.
3 If you print a correctly exposed negative first, then a comparison of the various prints on the contact sheet will be a guide to exposure times.
4 A contact sheet can help you organise your order of work when printing. This can be done either by grouping the negatives into thin, correct and dense to cut down on the exposure changes; or by grouping the negatives into those that require smaller and bigger degrees of enlargement.
5 Examine your contact prints with a magnifying glass. You will be able to see which negatives, if any, are blurred (camera shake) or out of focus.
6 Using a magnifying glass, you can check to see which is your best shot by checking such details as composition, the expression on people's faces, etc. You can also decide which parts of the negative you will leave out in the final print.
7 Technical details can be written on the contact sheet: for instance, the exposure time, the aperture and the enlarger height when a particular negative was enlarged. You can also write log book details on your contact sheet.
8 The contact sheet should be filed with the negative filing sheet (p.40), with prints and negatives in the same order.

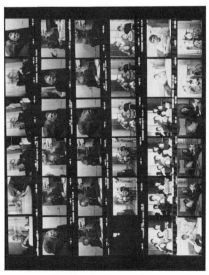

A contact sheet

Making a contact sheet: a step-by-step guide
Remember: white light off; safelight on

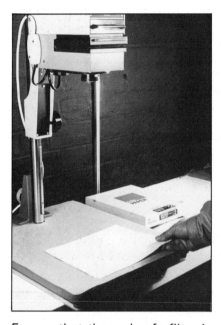

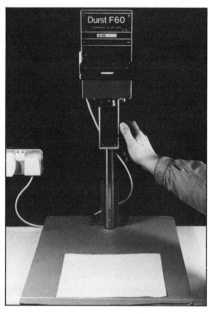

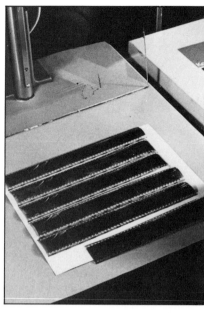

Ensure that the red safe filter is over the enlarging lens. Place a sheet of paper emulsion (shiny) side up on the baseboard. *Make sure that you replace the lid on the paper box.* Switch on the enlarger.

Raise and lower the enlarger and focus, until the area of light is covering an area slightly bigger than the paper.

Lay the negatives, all the same way round, on top of the paper. Make sure you put them emulsion side down, shiny side up. Carefully cover them with a sheet of clean glass (slightly bigger than the paper).

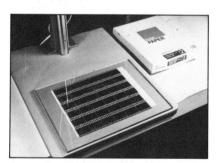

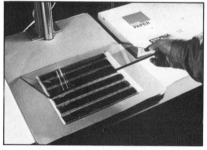

Close down the aperture of the lens to a setting which is exactly half-way between fully open and fully closed (usually f8). Turn off and move away the red filter. Expose for ten seconds. You could do a test first: using a small piece of paper, develop it to work out the correct exposure.

Carefully lift up and remove the sheet of glass. Slide your negatives on to clean piece of paper. Keep them in order, in case you have to do another exposure.

You are now ready to develop your sheet of paper.

Developing your prints

Developing prints in the darkroom, particularly your first few, can be the most exciting part of the whole photographic process. It is the stage when you finally see the results of your work and re-create the picture you visualised through the camera viewfinder. Under safelight conditions you can watch your photograph gradually appear. The thrill of watching this moment never really wears off.

The processing sequence of *develop, stop* and *fix* is the same as for film emulsion. It is important to use **paper (or 'bromide') developer** for your prints – not film developer. You can use the same type of stop bath and fixer. Water is quite adequate as the stop bath for print development.

The four factors of *time, temperature, dilution* and *agitation* are important when the paper is in the developer.

Setting up

Before you start printing, you must assemble the equipment and mix the chemicals. The photograph shows the equipment you will need to assemble on the wet bench.

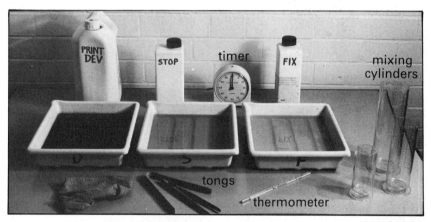

Equipment for developing prints

The chemicals can irritate your skin. Use gloves when mixing, and tongs when processing.

Follow the instructions carefully when mixing up the chemicals. The print developer is poured away after your printing session as it becomes exhausted. The stop and fix can be re-used, but you should check periodically that they are not exhausted. (Certain brands of stop bath change colour when this happens.)

Always use the same tray for the same chemical to avoid mixing (**contaminating**) your chemicals. Colour coding or marking the trays is a useful practice. Do the same with the tongs.

Bring or mix your working solutions to the correct temperature. Pour them into the trays to a depth of about 12 mm.

Exposing and processing prints must be done in safelight conditions. Always turn your enlarger off when not in use.

Developing your print: a step-by-step guide

1 Keep a cloth handy to wipe up any spillages.
2 You can cover the wet bench with old newspapers.
3 Make sure you have a towel to dry your hands.

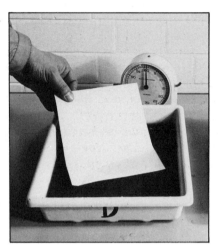

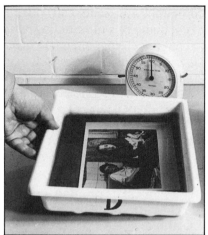

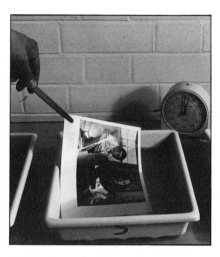

Slide the paper under the surface of the developer, emulsion side down to begin with. Start timing. Develop for the time given in the developer instructions for the type of paper you are using (usually two minutes).

Remember to turn the paper over so that the emulsion faces you. The image should begin to appear after 30 seconds. Gently rock the dish or agitate the print. Always develop for the full time. After the time is up, lift the print by the corner using tongs and let the developer drain off.

Slide the print into the water or stop bath. Place developer tongs over the lip of the developer tray. Agitate the print gently for about 30 seconds.

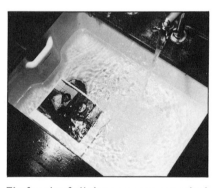

Using the stop or fix tongs, lift the print out by its corner. Allow the liquid to drain off.

Slide the print into the fixer, face down to begin with. Gently rock the tray. Turn the print over after one minute. After checking all papers are safe in their box, you can turn on the white light. Examine your prints. Do not have too many prints in the fixer at the same time.

Fix for the full time recommended in the fixer instructions for the type of paper being used. (For resin coated paper, usually two minutes; for bromide paper, ten minutes.) Then wash the prints (bromide for at least 25 minutes; resin coated for five minutes).

If your print is too *dark, reduce* the enlarger exposure time or *stop down* the lens.

If your print is too *light, increase* the enlarger time or *open up* the lens.

After fixing, it is important that a print is thoroughly **washed**. If the fixer and dissolved silver salts are not washed out, the print may discolour with time. **Resin coated (RC) papers** require less washing time, because the resin coat prevents the paper base soaking up too much fixer. The resin coat, however, is easily scratched when wet; so handle it carefully. Wash prints in a sink fitted with a syphon tube in the plug hole. You could also use a modern 'automatic' print washer.

RC papers must be allowed to **dry** naturally, face up, on a clean dry surface such as photographic blotting pads. Use a squeegee on both RC and bromide prints to squeeze out excess water. Bromide prints can be dried on a flatbed print dryer. Double weight paper dries flatter than single weight. Drying bromide prints face down prevents excessive curling.

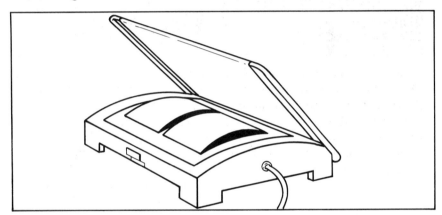

A flatbed print dryer

Making a print (enlargement)

Having chosen a negative to print, you must first make sure it is absolutely clean before placing it in the negative carrier. Dust can be removed with a blower brush. Drying marks *on the shiny side only* can be removed with liquid negative cleaner. Your enlarger condenser and negative carrier should be kept clean.

Making a test-strip: a step-by-step guide

Before making your print you must work out the correct exposure time. This is done by exposing a **test strip** of paper for different times. The strip is laid across the most important part of the negative area.

The amount of exposure required will depend on:
1 the density (degree of darkness) of the negative
2 the amount of enlargement (enlarger height)
3 the grade of paper being used
4 the contrast of the negative.

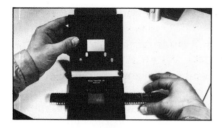

Adjust the masking frame to the correct size for the paper being used. Place the clean negative in the negative carrier (shiny side up). Place it, or use the carrier's masking device, to cut out the rest of the negative strip.

Carefully replace the carrier in the enlarger. Open the lens to the maximum aperture to aid focusing. Switch on the safelight and the enlarger. Turn the room light off.

Adjust the enlarger height and focusing controls until the image on the masking frame is the size you require. Check that the image is sharply in focus, taking into account the thickness of the paper. You could use a focus magnifier.

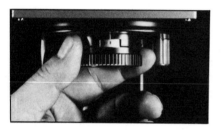

Set the aperture to halfway (usually f 8) for good average negatives. (A stop over (f 5.6) for dense negatives; a stop under (f 11) for pale negatives.) Do not change the aperture when making more prints from the same or similar density negatives. Switch the enlarger off.

Cut off a strip of paper about one-third the width of the paper you are using. Swing the red filter over the lens and switch the enlarger on. Lay the strip, emulsion (shiny) side up, across the most important part of the image which contains a range of tones.

Keep the strip flat using the edges of the frame or some coins. Cover four-fifths of the strip with a piece of card. Remove the red filter. Switch on for five seconds. Switch the enlarger light off.

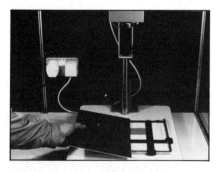

Move the card so that two-fifths of the strip are uncovered. Be careful not to accidentally move the strip when you are moving the card. Turn on for another five seconds.

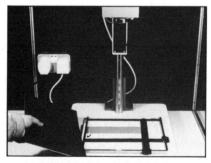

Continue like this in five-second stages for the remaining three-fifths of the paper.

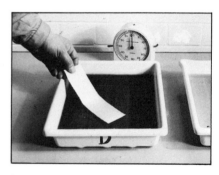

Process the test strip as described on page 52. Make sure it receives exactly the right amount of development.

A test strip

After fixing you can examine your test strip in white light. Carefully judge the one-fifth that gives the effect you want. The contrast and range between dark and light tones should resemble the original scene. This section may be in the middle of your strip. It may be a time in between two of your steps. Wherever it is, you can work out the correct exposure required.

The final print

Place a whole sheet of paper, emulsion side up, in the masking frame. Expose for the time you have worked out, being careful not to alter the aperture. You can check that the position of the masking frame has not moved by switching on with the red filter over the lens, then switching off. Process the paper as described on page 52. In the developer, the print may appear to be going too dark. Always give your print the full development time as it is difficult to judge under safelight conditions.

Points to remember

1 Try to use the lens at an aperture half-way between fully open and closed. You will be using the most effective part of the lens. Exposure times will be long enough for you to improve the print (see page 102). Because of the depth of field, the image will be sharper than if a wider aperture was used (see page 61).
2 Pale, thin negatives will require less exposure time; dark, dense negatives will require more.
3 Normal negatives are printed on grade 2 or 3 paper, high contrast negatives on grade 1, and low contrast negatives on grade 4.
4 When the enlarger is close to the masking frame, the concentration of light in a small area will require only a short exposure. As the enlarger is lifted, the light is dispersed over a larger area which will demand a longer exposure – sometimes very much longer.

Examining your print

Examine your print to decide whether the exposure time and contrast are correct. Your print may appear to be too high in contrast: that is, there is no detail in the highlights or shadows. This is often the case with pictures taken on a bright, sunny day. If taken on a dull, overcast day, your print may appear flat and grey, without a deep black.

Too much contrast

Too grey

A correctly exposed print will show a complete range of tones. The ideal is to give the print the minimum exposure that will produce a deep black tone *and* show detail in the highlights and shadows.

Selective enlargements

It is possible to improve your prints by the technique of **selective enlargement**. This is done by moving the enlarger head and the negative further up the column, making the image bigger.

Selective enlargements can improve your pictures in two ways:

1 by cutting out any unwanted parts

Cutting out unwanted areas of a picture

2 by selectively enlarging a part of a picture so that you create a totally new picture.

Selectively enlarging one part of a picture

Graininess

Points to remember

1 Moving the enlarger head further up its column will increase your exposure time. Therefore you must do a new test strip. Because you double the enlarger height, it does not mean that you just simply double the exposure time. The beam of light also spreads out over a much wider area as the lens gets further away from the baseboard.

2 The same effect could be achieved by adjusting the metal strips of your masking frame. The exposure time will remain the same, but the result will be a smaller picture and a waste of printing paper.

3 By enlarging your negatives you are also enlarging the grain structure of the negative, which can give your print a **'grainy'** appearance. Therefore a selective enlargement will look less sharp than the original print. Any error when taking the picture (such as incorrect focusing) will also be enlarged, as will any dirt or dust on the negative.

General points on printing

1 Keep old prints or spoilt sheets of paper of different sizes. Write the size on the back and use them when adjusting the masking frame.

2 Always use the trays in the same order: *develop, stop* and *fix*, with the developer tray nearest to you.

3 In winter, the temperature of your developer will drop, affecting the exposure time of your print. Dish warmers can be used. Alternatively, you could start off with a small amount and then top up with more warm developer.

4 Always develop your prints fully. Prints that go dark too early and are snatched out of the tray, have a poor range of tones. Cut your exposure time and develop for the full time.

5 Any print developer can be used with resin coated papers, although the special RC developer will give a short developing time. If, however, your fixer has hardener in it, you must wash the RC paper for the recommended time.

6 Do not put too many prints in the fixer at the same time. They will stick together and not fix properly. You must use enough fixer and agitate the prints in it regularly.

7 Never rush the processes. Standardise on agitation. If you cut back on the recommended fixing and washing times, you will make your picture less permanent.

8 Use tongs carefully: it is easy to scratch your print.

9 Remember to keep your enlarger clean. Check the negative carrier and condensers.

10 Use a blower brush on each negative before you print it.

Cleanliness pays off

What have your learnt so far?

1 In what way does a direct enlarger differ from a reflex enlarger? What are the advantages and disadvantages of each type?

2 What is the function of (a) a condenser, (b) a negative carrier, (c) a red filter, (d) a masking frame and (e) an electronic timer?

3 What are the differences between resin coated and bromide paper? What are the advantages and disadvantages of each?

4 You are using a paper box labelled 'RC 12.7 × 17.8, grade 3, glossy, double weight'. What do these terms refer to?

5 What factors will affect the amount of exposure a print will require?

6 What are the following pieces of equipment used for: contact printer, safelight, film wiping tongs, blower brush?

7 Which way up (emulsion up or emulsion down) should a negative lie (in relation to the paper) in a negative carrier? Which way up should the paper lie in the masking frame?

8 Give reasons for making contact prints.

9 Delete the wrong word in the following sentence:
Too black a print is caused by *underexposure/overexposure.*

10 Why is it necessary to wash a print after fixing?

11 Why do you stop down the enlarging lens when making your print?

12 Complete the following sentences.
For negatives high in contrast, use a _____ grade of paper.
For negatives _____ in contrast use a hard grade of paper.

13 Delete the wrong word in the following sentences.
a Moving the enlarger head further up its column requires *more/less* exposure.
b A harder grade of paper requires *more/less exposure.*

14 What might be the reasons for the following print faults?
a no picture at all on the paper
b paper completely black
c white hairs and specks on the finished image
d final picture too dark
e final picture too grey and low in contrast
f the picture stains when the white light is switched on
g picture is blurred.

15 Complete the following sentences.
Leaving the lid off the printing paper box could result in the paper being _____.
You work out the exposure time for a print by doing a_____.

16 A darkroom is divided into a 'wet area' and a 'dry area'. Explain why.

Chapter 6

Making the most of your camera

In Chapter 3 we saw that a whole set of combinations of shutter speeds and apertures were all capable of giving correct exposure. As well as controlling light, aperture and shutter speed also control sharpness.

1 The shutter speed affects the way that moving objects are shown (either sharp or blurred).
2 The aperture controls the area (or field) of sharpness in your picture. This area is known as the **depth of field.**

Varying shutter speed

You will probably have noticed that when you photograph a still object, altering the shutter speed has no effect on the image. Remember: *hold the camera steady; squeeze the shutter gently.*

Practical things to do . . .

Take a camera out to a suitable location where you can *safely* photograph fast moving traffic in both directions.

1 Take a car moving quickly past you on the side of the road *nearest* to you (a) at a shutter speed of 1/250 s and (b) at a shutter speed of 1/60 s.
2 Take a car moving quickly past you on the *other* side of the road (a) at 1/250 s and (b) at 1/60 s.
3 Take a car moving *towards* you (a) at 1/250 s and (b) at 1/60 s.
4 Take a person walking past (a) at 1/250 s, (b) at 1/125 s and (c) at 1/60 s.

1/125 s

1/60 s

1/125 s

1/250 s

1/125 s

1/500 s

5 Take a plane flying overhead (a) at 1/500 s and (b) at 1/60 s.
Examine the prints, and you will notice a change in the image when:

1 the shutter speed changes
2 the speed of the subject changes
3 the angle of the subject changes
4 the distance of the subject changes.

When photographing moving subjects, you have to decide whether you want to 'freeze' the final image so that it will appear sharp and clear, or whether, perhaps, you would like to 'blur' it a little, in order to create a feeling of movement.

It isn't always possible to have a wide choice of shutter speeds. *In poor lighting conditions you will be restricted to a slow shutter speed.* To overcome this problem you can use the technique of **panning** the camera, which will make the image sharp, but the background blurred. This technique involves tracking the subject with your camera as it passes you.

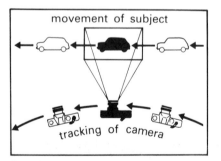

Panning

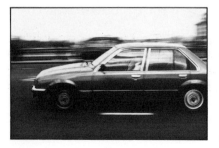

Panning

1 Decide where you will take the picture and stand square on this point, with your feet apart. Focus on the point where you know the subject will pass.
2 Twist the body and locate the subject in the viewfinder, as it approaches. Follow the subject smoothly in the viewfinder as it passes by, taking great care to keep the subject in the same part of the viewfinder. Keep the camera steady and at the same height as you track the subject.
3 When the subject reaches the point you have focused on, press the button gently as you pan. Continue to pan and follow through after you have taken the shot.

You will need to pan the camera for extremely fast subjects that pass you, such as at a motor racing circuit or a flying display. This is because your camera doesn't have a fast enough shutter speed to 'freeze' the subject.

You can try panning for its creative effect in any lighting condition.

A tripod with a pan-and-tilt head is a useful accessory when panning. It keeps the camera level through the panning movement and makes it easier to track the subject smoothly.

Tripods and shutter speed

The main function of a tripod is to support the camera and hold it still when using shutter speeds slower than 1/60 s. If you were to hold the camera and take a picture at such a slow shutter speed, you would almost certainly shake the camera, resulting in a blurred image.

Focal length and shutter speed

If you fit a long focal length (**telephoto**) lens on to your camera, the problem of camera shake becomes more critical. This is due to the additional weight of a longer lens, making the camera top-heavy and difficult to hold still. You must use a fast shutter speed or a tripod (or an alternative means of support such as resting on a wall).

As telephoto lenses magnify a distant subject into something that appears nearer, any movement (shake) of the camera and lens also tends to be magnified. This is another reason for using faster shutter speeds with telephoto lenses.

Summary

Factors to take into account when deciding on what shutter speed to use are:
1 the amount of light
2 the speed of the subject
3 whether you wish to achieve a sharp or blurred effect
4 the distance of the subject from the camera
5 the angle of the subject to the camera
6 the focal length of your lens
7 camera shake
8 the speed of film.

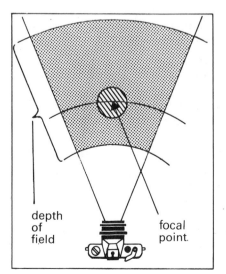

depth of field

focal point.

Altering the aperture (depth of field)

If you study a photograph closely you will find that the main subject you have focused on is sharp, but there is an area (or field) *in front of* and *behind* the subject which is also acceptably sharp. The distance between these two points (in front and behind) is known as the **depth of field**.

Changing the size of the aperture changes the depth of field and determines how much of the final picture will be in focus.

Practical thing to do

Find a row of closely spaced objects receding into the distance, such as parking meters, fence posts or closely parked cars. Take a light reading, and take three shots with the camera focused at the same distance (say 6 m). Take one shot at aperture f 4, another at f 8 and the last at f 16.

At f 4 *At f 16*

Take another three shots, this time keeping the same aperture but altering the focusing distance in each to 1.2 m, 4 m and 10 m.

By examining your first set of photographs you will discover that as the size of the aperture *decreases,* so the depth of field *increases* (more of the picture comes into sharp focus). The depth of field *decreases* as the aperture size *increases.*

In a photograph, the change from a sharp area into an unsharp area is gradual but nevertheless the point at which it begins can be pinpointed fairly accurately.

By examining your second set of photographs, you will also notice that as the focusing distance increases, so the depth of field increases.

Focused at 1.2 m *Focused at 4 m* *Focused at 10 m*

Focal length and depth of field

The focal length of your lens will also affect the depth of field. The shorter the focal length of your lens, the greater the depth of field. It is a characteristic of **wide angle lenses** that everything in front of the

camera looks sharp, even at short focusing distances. Long focal length lenses require more accurate focusing on the main subject because of the very shallow depth of field.

In a picture the area of sharpness behind the subject you have focused on is bigger than the area of sharpness in front of the subject. This can be seen clearly if you learn to understand the depth of field scale on your camera lens.

Wide angle lens

Telephoto lens

Depth of field scale

When you have focused your camera it is possible to read, from a scale on your lens barrel, the depth of field you will obtain at the various apertures. In the diagram, the lens has been focused on a subject 3 m (10 ft) from the camera. The scale shows that at an aperture of f 8 subjects between 2 m (7 ft) and 5 m (15 ft) will all be acceptably sharp. The depth of field is therefore 3 m.

Most automatic lenses have a **stop down key** (depth of field preview button) which enables you to stop down to the aperture you have set before you take a picture. If you study the shot in your viewfinder with the key depressed, the image will be dim, but you may actually be able to see the limits of the depth of field.

If you were focusing the camera lens on infinity at a small aperture size, such as f 8 or f 11, you would see that on the depth of field scale there is no distance greater than infinity to its right on the scale. If you turned the infinity mark a little to the right and kept it within the depth of field mark for the aperture being used, you would have considerably increased the ground within the depth of field. This is called setting the lens at its **hyperfocal distance**. The hyperfocal distance can be defined as the distance to the nearest object which is just acceptably sharp when the lens is focused on infinity. Using the hyperfocal distance is useful for landscape photography.

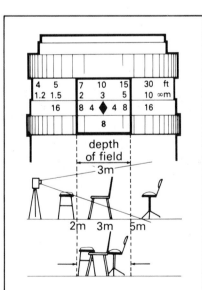
By grouping objects together within the limits of the depth of field, we can ensure that they will all be sharp.

Using depth of field

Depth of field can be used creatively to isolate a subject and make it stand out against its background. This is a useful technique for portraits. It is possible to lose unwanted or unsightly backgrounds by making them blurred, or add mood to a picture by including an important but blurred foreground. All this can be done by using a large aperture which gives a shallow depth of field. This creative technique of combining careful focusing with a shallow depth of field is called **selective focusing**.

Selective focusing

It is possible to make the foreground and background as sharp as the main subject (as in a landscape) by using a small aperture which gives a greater depth of field.

To have more in focus in the picture	To have less in focus in the picture
Use small aperture	Use large aperture
Increase focusing distance	Decrease focusing distance
Shorten focal length	Increase focal length
Space objects together	Space objects apart

Summary

As we saw in Chapter 3, the aperture and shutter speed control light, but now we have discovered that they also control sharpness.

By controlling the camera and its shutter speeds it is possible to:
1 have both the main subject and the background sharp
2 blur the main subject against a sharp background
3 have a sharp main subject against a blurred background
4 blur both main subject and background.

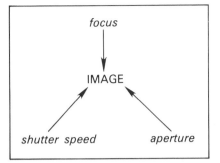

When taking a photograph you may sometimes have to compromise on the aperture or shutter speed you want to use because of the lighting conditions. With more experience, however, you will be able to select the aperture or shutter speed that will give a particular effect. By using these two camera controls together with the careful and thoughtful use of the focusing control you can alter the appearance of the image in almost any way that you want.

By realising the full potential of these three camera controls (aperture, shutter speed and focusing control) you will be starting to create pictures rather than just taking ordinary photographs.

The shutter speed controls

Light (*time* shutter is open)
Sharpness (*movement* of subject is shown frozen or blurred)

The aperture controls

Light (*quantity* let in by iris)
Sharpness (*depth* within the picture that is in focus)

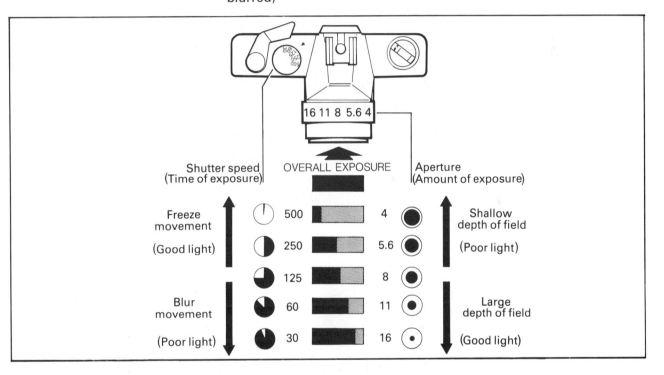

Two photographs taken with the same overall exposure

At f 16 and 1/30 s

At f 4 and 1/500 s

The art of composition

In the excitement of taking your first pictures you will often make basic mistakes, such as accidentally tilting the camera. With practice you will soon learn to avoid such simple mistakes of composition.

Composition is the careful arrangement or balancing of the various ingredients of a picture. As you gain more experience in this skill, you will instinctively compose your photographs before you shoot.

Composition has traditional rules that can be learnt. When these rules have been understood, you are then in a position to follow them or break them, intentionally rather than accidentally.

Before you compose and shoot a photograph you must always be sure that it is worth taking in the first place. This is not to say that a simple record shot of something that interests you is not worth taking. With all other photographs you should be sure that the composition will seize the attention of any viewer.

The art of composition is one of the most powerful skills a photographer can use to ensure that his or her photographs have impact.

Some basic guidelines to composition

1 You must decide whether a horizontal (landscape) or vertical (portrait) format is more appropriate for your subject. Horizontal compositions, especially ones involving horizontal lines, often give a restful, peaceful effect. Vertical compositions, especially involving vertical lines, are usually more dynamic.

Portrait

Landscape

2 What is the main point of interest in your picture (its focal point)? Decide if you are going to place it symmetrically or asymmetrically within the frame. Are you going to show it simply? If not, are any objects near the edge distracting?

Symmetry

Asymmetry

Symmetry/asymmetry

3 Although the main subject can be near to or far from the camera, it is often pleasing when you place it off-centre. A focal point placed one-third or two-thirds across the picture is usually better than one that cuts the picture in half. Similarly, a horizon is best placed one-third or two-thirds up the height of the picture, rather than in the centre. The horizon can be raised by crouching down.

Picture split

Low horizon

4 Remember that you are creating a two-dimensional image of a three-dimensional world. Sometimes a strong but subdued foreground framing the picture can give added depth to a picture. Likewise, the lines of a road or a fence can add depth. Fortunately a photographer does not have the same problems with perspective that a painter has. Avoid lines leading away from the main subject and out of the viewfinder. If this is happening use a 'stopper' (see page 72).

Foreground features for depth

Lines leading the eye into the picture

Framing the subject

Balanced tone

Unbalanced tone

5 The way in which you arrange the large areas of tone within a picture can make it appear either a balanced or an unbalanced composition. Good tonal balance will show up clearly if you hold the picture upside-down.

Changing the angle of the camera

6 Changing the angle of the camera can create an interesting or dramatic effect.

Moving in closer to show up detail

7 Moving in closer to show a detail can create a whole new picture, pull together two previously separate and unrelated subjects, or prevent uninteresting photographs that have no centre of interest (focal point).

8 Small figures can contrast with and give scale to a photograph.

Using figures to give scale to a picture

9 It is often said that we 'read' pictures from left to right (like writing). Most people would probably prefer the photograph showing the person walking left to right. Avoid people walking out of the picture near the edge.

Changing the direction of movement in a picture

10 These two photographs intentionally 'break the rules'. In one, the photograph is split into two halves. In the other, the people are walking out of the picture. Sometimes you may want to 'break the rules' in order to create an interesting and unusual picture.

Two photographs that 'break the rules'

How to avoid simple mistakes in your pictures

1 Be careful not to tilt the camera

When this picture was taken, the camera was slanting or tilting to one side. To avoid a sloping horizon hold the camera level, i.e. parallel with the ground.

Here, the photographer has moved back and tilted the camera up in order to get in all the building. The converging verticals make the building look as though it is falling over.

An alternative way to shoot the same building is to move in close and shoot straight up. Pictures like this can be very dramatic. You could also stand further back using a standard lens and crop the foreground when printing.

2 Be careful with the background

Here the photographer has stood the subject in front of another distracting object, not realising how ridiculous the final photograph might look. Also avoid your own shadow falling on the foreground.

Here a distracting background is 'clashing' with the main subject of the photograph.

Here the photographer has moved closer to the subject and thrown the background out of focus by using the shallow depth of field of a wider aperture. He or she could also have chosen a simpler background.

3 Be careful about the subject-to-camera distance

Here the subject is too close to the camera and is out of focus. Check you know your minimum focusing distance.

In this uninteresting shot the subject is too far away. The foreground is very empty, leaving little to interest the viewer.

By filling the picture frame you can make a far more interesting picture.

4 Do not accidentally cut off parts of the picture

Take care not to obstruct your view with your fingers, cable release or camera case.

With viewfinder (non SLR) cameras it is easy to cut off the picture at close distances. This is known as the problem of **parallax.**

Always check carefully to see what is included and what is excluded in your viewfinder before shooting.

More guidelines for adding impact to your pictures

Remember that all your shots need not be taken from a standing position. Try experimenting with different camera positions: crouching down, lying on your stomach, or standing on a chair. These can all add impact to a picture.

Exploit unusual angles

Look for unexpected details.

Extreme close-ups of a detail can reveal more than a general view.

Look down as well for an unexpected bird's eye view.

Compose on the diagonal

Use a 'stopper'

A horizontal composition is often considered static and restful.

A composition across the diagonal of the picture gives more impact.

A stopper can be used when lines lead away from the main subject and out of the frame.

Shoot against the light

In most situations the light source will be behind or at the side of the camera. Very dramatic effects can be achieved by shooting into or against the light source. This technique is sometimes known as **'contre-jour'**.

Use strong shadows

The strong shadow cast by a subject can often add to or even make a very dramatic picture.

Use reflections

Reflections in water, glass or metal can also add to or even make a very dramatic picture. Reflections in water can be 'broken up' by throwing in a stone.

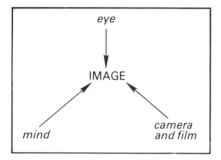

The art and craft of photography

We know that a photographer must master the basic technical skills of photography. An understanding of the rules of composition is an aid to successfully organising the various ingredients of your picture. Once the *craft* of photography is mastered, the art of photography can be discovered by training your eye to 'see' the picture-taking possibilities within a situation or surrounding.

It can take an artist many years to train his or her eye and mind to 'see' and interpret the interesting and varied world around him or her. Likewise a photographer should make his or her eye, brain and camera work as one.

Here are five ideas for subject matter that artists have explored in their work for centuries. Each idea on its own is a subject for an interesting and creative photograph.

1 Texture
2 Form
3 Shape
4 Light
5 Pattern.

The importance of lighting

The way in which light falls upon a subject can occur naturally (by daylight), or be controlled artificially (by **photoflood** lights and **flashguns**). The strength *and* direction of a light source can enhance or subdue the texture, form, shape or pattern of a subject.

For more about natural and artificial light, see Chapter 8.

What have you learnt so far?

1 A fast car travelling past the camera will look ____when photographed at 1/60 s. In order to 'freeze' its movement you should use a shutter speed of ____.

2 What are the slowest shutter speeds that you could use in order to 'freeze' the movements of (a) a pedestrian, (b) a cyclist, (c) a car and (d) a racing car moving past close to the camera?

3 What technique could you use with a slow shutter speed on a dull day in order to 'freeze' the action of a passing car? Describe the technique.

4 Why is a tripod necessary when using shutter speeds slower than 1/60 s?

5 Would you tend to use slower or faster shutter speeds with a telephoto lens? State why.

6 What factors do you take into account when deciding on a shutter speed?

7 Using a diagram explain what is meant by 'depth of field'.

8 Are the following statements true or false?
 a f 8 gives less depth of field than f 4.
 b A wide angle lens gives less depth of field than a telephoto lens.
 c A focusing distance of 5 m will give more depth of field than a focusing distance of 1 m.

9 Describe the depth of field scale on your camera lens. How would you set your lens to the hyperfocal distance on a bright day when focused on infinity in a landscape? What would be the advantage of doing this?

10 Compare how shutter speed and aperture can control the sharpness of the image. How do they each control the light entering the camera?

11 Fill in the missing parts of the following table.

Aperture	+		= Exposure	
Small aperture	+	Slow speed	= Large depth of field :	
Large aperture	+		= Small depth of field :	Freeze
	+	Fast speed	= Large depth of field :	Freeze
Large aperture	+	Slow speed	=	: Blur

Practical things to do . . .

1 Make up a chart showing which shutter speeds to use with different subject speeds.

2 Make a viewing screen so that you can practise composing shots. Cut a neat rectangular hole in a small sheet of card, making sure that the hole is the same proportion as a 35 mm negative.

3 Produce a sequence or series of shots that go to make up a record strip of a brief action or event. The event should involve subjects which move at different speeds. For instance, a train entering a station; doors opening and closing with people getting on and off; the train leaving the station.

4 Choose a natural subject such as a tree, a flower or a large rock. Produce a set of five photographs which each illustrate one of the following: texture, form, shape, light, pattern.

5 Choose a subject such as a tree, car, person, church, house, hill, pond, square or street near where you live or study. Produce a set of between eight and twelve photographs which each use a different technique of composition.

Chapter 7

Hints on basic practical photography

Photography is a vast subject with many aspects to it. To reach a high standard, technically and pictorially, some photographers specialise in particular aspects which often involve specialist techniques.

Whole books are written about just one aspect of photography, such as landscapes or portraits. In this book we are mainly concerned with the basic practical approach, but the following suggestions may whet your appetite.

Photographing landscapes (in the countryside)

Many of the *basic guidelines to composition* on pages 66–9 cover some of the approaches you can use for landscape photography, especially numbers 1, 3, 4 and 8.

The sky is an important element in any landscape. At times it can be the main subject in its own right. Be careful it does not affect your meter reading.

Do not be afraid of shooting in unusual weather and exploring the different seasons of the year. Photographs taken early in the morning or late in the evening, in snow, rain or mist, can often be very striking. Try to make your views interesting by including a feature such as an unusual tree, a barn or a church, thus giving scale and adding a focal point to the scene. Don't forget the beautiful natural shapes, patterns, forms and textures, that can be caught in close-up shots of flowers, trees, leaves etc.

Useful equipment: tripod, wide angle lens, telephoto lens, filters, close-up lens.

Photographing buildings, towns and cities (cityscapes)

You may have to wait several minutes if you do not want too many people or traffic in your picture of a building. In a town or city, look out for interesting contrasts between old and new buildings. You could use part of one building, such as an arch or window, to frame your shot of another building. You may have to alter your camera angle if you do not want an advertisement or traffic sign to spoil your shot. Look up for interesting details and buildings.

Remember some of the basic guidelines on composition and impact. Avoid converging verticals, or exaggerate them deliberately.

Useful equipment: tripod, wide angle lens, telephoto lens, orange filter.

Panoramas

You can take a very wide view (a **panorama**) of a landscape or cityscape, by taking several photographs from the same position and joining them together. Use a tripod and note a landmark at the edge of each picture and include it in the next so that they overlap. To join the prints, line them up, cut off the overlaps and mount them on a piece of card.

Photographing people: portraits

Decide whether the picture will be relaxed and informal or more formal and posed. Will the person be standing or sitting? Will they be looking into the camera or not? Do not stand the person too far away. Do not ask them to squint into the sun, hold a smile too long, or look out of the picture. A hazy sky outdoors is ideal lighting. Decide whether you are going to photograph the whole person or just the head and shoulders. With a full face, a natural pose is one with the head slightly tilted. When shooting a face at an angle **(three-quarter view),** focus on the eye further from the camera.

If somebody has a particular occupation or hobby, photograph them doing something connected with it. Or you could include a background or objects that reveal something about the person. When photographing small children, hold the camera down at their level. Be careful in arranging groups: tall people at the back, others kneeling or sitting at the front.

Useful equipment: tripod, artificial lighting, 105 mm or 135 mm lens. (These telephoto lenses enable the photographer to stand further away and avoid embarrassing the subject. Standard lenses distort faces: wide angle lenses more so).

Photographing people: candid shots

This type of photography involves photographing people usually without them knowing that they are being photographed. This is a technique that photo-journalists (newspaper photographers) often use.

A telephoto lens is very useful in order to isolate the subject, and allow the photographer to remain unnoticed. You may have to shoot quickly and even 'grab' shots. You could compose a picture in advance. For example, you can take a light reading off a similar tone and estimate the focusing distance in advance of the best moment to shoot. The exact instant at which to take a picture in a 'candid' situation is very important.

Find a book about the French photographer Henri Cartier-Bresson. Study his photographs, as he is a master at this type of photography.

Useful equipment: telephoto lenses (135 mm or 200 mm), rangefinder, hand-held meter, fast film (for poor weather).

Photographing action and sports

The section about shutter speed in Chapter 6 is very relevant to action and sports photography. Using shutter speed to either blur or freeze movement is an essential technique, as is panning. Another way to freeze action is to catch it at the instant when there is the least movement. For instance, at the moment when a highjumper is just clearing the bar and is neither going up nor falling down. You may have to work out focus, exposure and composition in advance.

Photographs taken too far away from the action will lack impact. (Telephoto lenses are very useful in action and sports photography.) Look for a good place to take your pictures. For instance, the starting or finishing point of a race, or the 'pits' of a motor race; also portraits of the competitors or people doing various jobs around the event. Move around and take pictures away from the action. Parts of the crowd might make interesting shots.

Useful equipment: tripod, long telephoto lens, fast film (for fast shutter speeds).

Photography in unusual weather

Do not be put off by unusual (or bad) weather conditions. Regard them as a challenge. Exploit the peculiarities created by different weather conditions.

Frost and snow

In frost and snow, trees and leaves take on a new dimension. Interesting patterns are created by tracks in snow. Increased light can create high contrast images.

Mist and fog

In mist and fog, very delicate shades of tone are created by objects receding into the distance. The feeling of depth created when objects lose tone and contrast as their distance from the camera increases is often referred to as **'aerial perspective'**.

Rain

In rain, look out for reflections in puddles, the interesting shapes of umbrellas and people huddled together, drops of water on glass and metal (shop windows and cars). A clear polythene bag can be used to keep rain off the camera. Cut a hole in the bag for your camera lens. Operate the camera controls keeping your hands and camera inside the bag. Or a friend could shield you with an umbrella, while you work.

Dull weather

In dull weather, try shooting silhouettes against the sky. Expose for the sky.

At night

Very successful photographs can be taken at night, by using a tripod, cable release and shutter speeds measured in seconds. Floodlit buildings, neon signs, and the lights of cars forming streams of light on the negative, are possibilities.

To obtain an exposure of several seconds, use the setting marked **'B'** on your shutter speed dial. At this setting the shutter remains open for as long as the shutter release button is being pressed. You will have to measure the seconds on your watch. Exposure at night is a matter of trial and error. Bracket some exposures beginning with three seconds at f 2.8 on 400 ASA film.

Very bright light

On a bright day at the seaside, in the mountains, or in snow, the high reflected light levels can affect your meter, resulting in underexposed negatives. You can use a **neutral density filter** or a film of much lower ASA number to cope with the high light levels. Well exposed negatives may still yield high contrast prints. Exploit the harsh lighting, which will give bleached highlights and strong shadows.

Useful equipment: tripod, cable release, high *and* low speed films, neutral density filter, ultra-violet (skylight) filter, clear polythene bag.

When moving your camera between extremes of temperature quickly, beware of any condensation that may form on the lens. At the seaside, always protect your camera against sand and water.

Using different lenses

As mentioned in Chapter 2, one of the advantages of the 35 mm SLR camera with focal plane shutter is that you can change the camera lens without fogging the film.

Interchangeable lenses are made in different focal lengths. The main advantage of changing to a lens of a different focal length is that you can include more or less of the view in front of the camera without having to change its position.

A focal length of 50 mm is accepted as 'standard', since the angle of view is close to that of the human eye and gives natural-looking results.

Longer focal length lenses (telephoto) such as 105 mm, 135 mm, 200 mm, and 400 mm, magnify an image in a similar way to a telescope. You can fill the frame with the image of a distant subject without having to move nearer.

50 mm lens

35 mm lens

28 mm lens

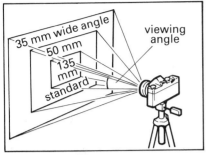

Shorter focal length lenses (wide angle) such as 35 mm, 28 mm, and 24 mm, include a much wider span of the view in front of the camera than a standard lens (they have a larger viewing angle). This means that more of the view can be included on the negative without having to move further back.

The maximum aperture to which a lens can be set affects how much light can pass through it on to the film. Lenses are often spoken of in terms of speed (as are films). An f 2 lens is 'faster' than a lens of f 4.

Spaciousness shown by using a wide angle lens

Focal length	Viewing angle	Use	Characteristics
300–500 mm	8–5°	Wildlife/sports	Give shallow depth of field. Telephoto lenses are usually 'slower'. Usually compress or flatten perspective. Useful for isolating subject. Increased risk of camera shake – may need tripod.
200 m	12°	Sports/candid	
135 mm	18°	Candid	
80–105 mm	30–23°	Portraits	
35–50 mm	62–46°	Standard 'everyday' lens	
24–28 mm	84–74°	Interiors and architecture	Give greater depth of field. Wide angle lenses are usually 'faster'. Usually extend or distort perspective. Useful for showing large subjects from close-to.
8 mm (fisheye lens)	180°	Interiors and panoramic effects	

Isolating the subject with a telephoto lens

A **zoom lens** is a single lens with an adjustable focal length. One part of the lens barrel can be pushed in or pulled out from the other part of the barrel. This alters the various elements of the lens in relationship to one another and enables you to slide easily from one focal length to another. A 28–70 mm zoom lens together with a 70–200 mm lens might replace as many as six separate lenses of fixed focal length.

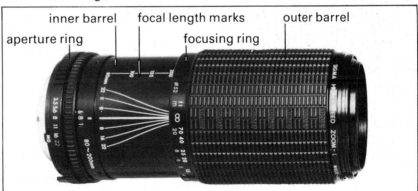

A zoom lens

Although convenient, zoom lenses can be bulky and complicated to use. They often have two separate controls: one for focusing and one for zooming (adjusting the focal length). They are usually not so fast as the equivalent fixed focal length lens and may not perform as well optically.

A **macro lens** is a lens which can be focused on objects extremely close to the camera (e.g. 6 cm). Both fixed focal length and zoom lenses can have this facility.

A **teleconverter** is an attachment that can be fitted in between the standard lens and the camera body. It converts the lens to a telephoto (of poorer quality than a manufactured telephoto) and affects exposure. It is a cheap and compact alternative to a telephoto lens.

135 mm	Telephoto lens of focal length 135 mm
f 4	Maximum aperture f 4, with non-automatic iris diaphragm
Pentax screw-fitting	Fits screw-on Praktika camera bodies
49 mm filter thread	Accepts 49 mm filters

Lens information

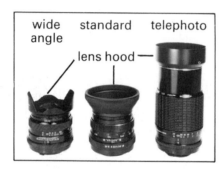

An automatic lens: the pin is pushed in by a lever on the camera body, and closes the iris diaphragm to the correct aperture at the instant the shutter release is pressed

Lenses can also be either manual or automatic in the operation of their iris diaphragm. In an **automatic lens,** the iris diaphragm automatically closes down to the aperture you have set at the instant the picture is taken. At all other times when you are focusing, the lens remains at its maximum aperture. If, however, you want to check the depth of field visually, you can press a depth of field preview button on the side of the lens, prior to taking a picture. With a **manual lens**, the iris diaphragm is always at the size of aperture set on the aperture ring. As focusing is easiest at maximum aperture you must always remember to turn the aperture back to the correct number indicated by the metering system before you take the picture. Manual lenses are cheaper but slower to use.

Interchangeable lenses should not be used as an excuse for the photographer to stay rooted to one spot. Moving about from side to side, backwards and forwards, to find the best composition is the basis of good photography. Additional lenses should be used when moving nearer or further away is impossible. Alternatively, you can exploit different lenses and their characteristics to achieve specific effects, thus creating more interesting pictures.

Filters

Filters affect the light rays which pass through them, altering the properties of the final image in some way. They are either screwed on or slipped over the front of the lens, and are made of optical glass, gelatin, or plastic.

Coloured filters lighten the same colour in a picture but darken the complementary colour, i.e. red will darken blue, but lighten red.

If the filter is not absolutely clear it will restrict some light and alter the exposure required. With TTL metering systems, any exposure change is automatically taken into account. If you are not using TTL metering, you will have to multiply the exposure by the **filter factor**, which is usually engraved on the filter.

If the correct metered exposure for a particular shot is f 11 at 1/125 s then using a filter of factor ×2, you should increase the exposure by one stop to f 8 at 1/125 s.

It is useful to check that a TTL metering system is in fact taking into account the change in exposure caused by a filter. This is done by comparing readings before and after placing the filter on the lens, and comparing the exposure change with a calculation based on the filter factor. Handle filters with the same care as you would a camera lens.

View without filter

View with yellow filter

View with red filter

Type	Effect	Use
Ultra-violet or skylight	Cuts down ultra-violet light and haze present in snow, mountain and beach scenes on bright days.	Left on lens continuously for protection, as it does not affect exposure. Adds contrast to hazy shots.
Yellow	Lightens yellow; darkens blue.	'Brings out' the clouds in a blue sky.
Orange	Gives extra contrast to blue.	Darkens sky even more. Used in architectural photos.
Red	Darkens blues and greens dramatically. Requires much more exposure.	Dramatises skies.
Polarising	Cuts down light rays reflected back at acute angles from surfaces such as glass and water.	Rotate filter until the reflections disappear.
Neutral density	Absorbs all light rays equally, cutting down the amount of light reaching the film.	When too much light is present to make the desired exposure.

All the above filters, except the ultra-violet skylight filter, affect exposure.

Camera outfit

A **camera system** includes a collection of lenses to fit the camera body, together with other accessories. A useful system might consist of camera body, wide angle lens, standard lens, short telephoto lens, long telephoto lens, tripod, cable release, lens hood, cleaning materials and some filters. It is wiser not to buy these altogether, but rather separately, as the need for a certain item is felt.

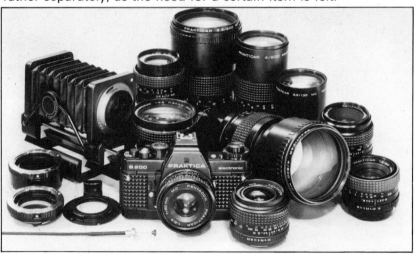

When building up your system, start with the lenses that you will need most. Remember to fit all lenses with the correct lens hood. These not only prevent 'flare' from a bright light source spoiling your film photograph, but also protect the front of the lens.

A photographic **gadget bag** is a useful container in which to carry the items you will need on a specific photographic outing. You might prefer to use a shoulder bag, which does not advertise to thieves that it contains valuables inside. Whatever bag you use, make sure it has padded foam compartments for the various bits and pieces of your outfit. Your bag should be big enough to carry your usual equipment. It should be strong and waterproof, but also as light as possible.

Items of equipment should not be allowed to rattle about inside. Lenses should be kept in separate bags or pouches, to stop them knocking and damaging each other. Keep your gadget bag packed neatly and ensure that you can quickly locate anything should you need it.

A camera outfit might consist of:

1 A gadget bag.
2 A lightweight tripod, which can be strapped to the bag. Remember to include a cable release in the outfit.
3 A changing bag for emergencies. You can improvise with a coat or jacket.
4 The basic camera system consisting of camera body, lenses and filters.
5 Spare batteries for your camera. Some automatic cameras will not work if the battery is dead. Spare batteries for your flash gun.
6 A small lightweight flash gun. Aluminium foil that can be used as a reflector.
7 Log book.
8 A separate hand-held light meter if you think it will be necessary.

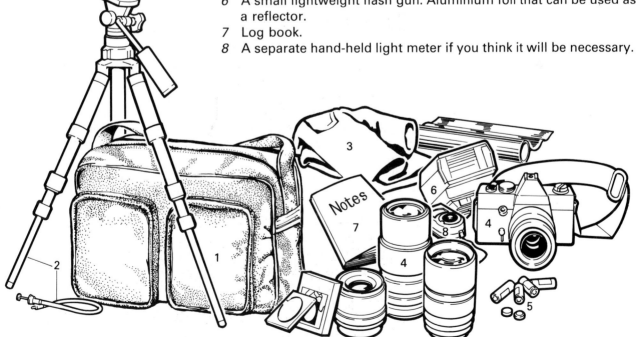

A useful camera outfit

Not only must you protect your camera outfit from theft, damage and dirt, but it will also benefit from regular cleaning and servicing. Always make sure that you understand the equipment's instructions. In the event of a malfunction, never repair it yourself; always have your repairs done professionally.

Remember to keep your camera parts clean. You can use a camel hair brush or 'dust off' aerosol to clean out inside your camera body. A cotton wool bud is useful for cleaning the eye piece. Always take great care when cleaning a lens surface. First use a lens brush for the dust, then gentle pressure with the edges of a rolled lens tissue or lens cleaner. Never rub your lens or use an impregnated cloth used for spectacles.

Film can be damaged if stored for long periods or exposed to heat. Do not 'cook' the contents of your gadget bag by leaving it for long periods in direct sunlight. Regularly check your camera and gadget bag straps and make sure they will not break, thus dropping expensive equipment.

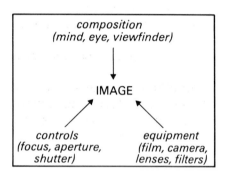

Summary

By making the most of your camera it is possible to decide exactly how the image will look in the final print. The three main camera controls, compositional skill, and equipment such as lenses and filters all interrelate with each other. Realising this will lead to successful picture taking.

Here is a procedure you could follow that takes into account many of the techniques outlined.

1 Choose a subject. Decide what effect you would like in the final picture. Will changing lenses or adding filters reinforce this effect?
2 Take a light meter reading. Will the aperture/shutter speed combination you choose add to the effect?
3 Compose the photograph. Walk around the subject, checking through the viewfinder. Do you need to frame the subject, or include a figure? Horizontal or vertical format? What angle? What distance? (Change the lens if necessary.) Position of focal point of picture within the frame?
4 When you have chosen the best position, look through the viewfinder again. Check for wanted and unwanted details and alignment. Final check on focus, exposure, and composition.
5 Decide on and take the picture at the best (decisive) moment.

The success of a picture often depends upon the photographer having the patience to wait for the best moment to press the button. He or she may have to wait for a figure to walk into the shot in order to fill a large, empty space, or for the sun to appear and cast an interesting shadow. However, do not take too long or you might lose the picture altogether; for example, the subject might move away or become obscured.

In certain situations you may not have time to make these deliberate decisions. It is always a help if you carry your camera with the focus and exposure controls pre-set, so that you can 'grab' that

unexpected picture. With practice you will be able to anticipate events and position yourself at the best place. Avoid the temptation to shoot off lots of pictures in the hope that the law of averages will give you one or two interesting photographs – it won't.

What have you learnt so far?

1 List a number of factors which could affect the sharpness of your print.
2 How do telephoto and wide angle lenses change the appearance of the subject when they are used?
3 List and compare four characteristics of telephoto and wide angle lenses.
4 What do (a) zoom, (b) macro, (c) teleconverter, (d) non-automatic and (e) maximum aperture mean, with reference to lenses?
5 Coloured filters *lighten/darken* the same colour in a picture but *lighten/darken* the complementary colour. (Delete the wrong words.)
6 If the correctly metered exposure for a particular shot is f 16 at 1/125 s, then what settings could you use if you added a filter of factor ×2?
7 What would you use (a) an orange, (b) a polarising and (c) a neutral density filter for?
8 How would you recognise and tell the difference between each of the following faults in your prints: (a) out of focus, (b) camera shake, (c) enlarger out of focus, (d) enlarger shake, (e) a fast moving object photographed using a slow shutter speed?

Practical things to do . . .

1 Using a tripod, make a panorama of either a cityscape or a landscape.
2 Compare two prints: one view taken with a telephoto lens and the identical view taken with a wide angle lens. Enlarge the wide angle shot so that the area of the subject shown is the same as in the telephoto picture. What do you notice about the two prints?
3 Is it right to photograph people without their permission? Discuss this question with your friends.
4 Photograph an object of several colours using different filters. Compare the resulting pictures.

Chapter 8

Lighting

As a photographer, you do not have to rely on the natural source of daylight. You can also use artificial sources of light. You can make use of four different types of light.

Outdoors (often sunlight)

Photofloods (often called 'tungsten')

Indoors (often called 'existing light')

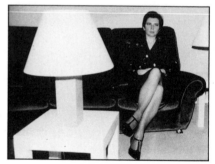

Electronic flash

We have seen that there must be enough light present to allow a correct exposure to be made. The way in which this light falls upon the subject can dramatically alter its appearance. The *strength, direction* and *quality* of light are key factors in the making of an interesting photograph.

By manipulating the strength, direction and quality of lighting we can reveal the roundness (form) or texture of a subject, capture a mood or create an effect.

The **strength** of light is the degree of brightness of a light source.

1 In natural daylight, this is varied by the time of day or year, and type of weather.
2 Indoors, it depends upon the strength of light from a window.
3 With photofloods it can be changed by the number and power (measured in **watts**) of the bulbs.
4 With flash it can depend on the power of the flashgun used. (This power is either given as a **guide number** or is measured in **joules**.)

The **direction** of light sources means the angle from which the light used strikes the subject.

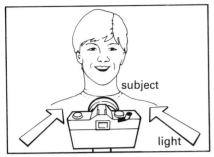

Front light

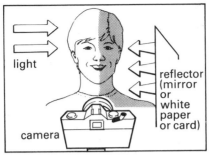

Side light

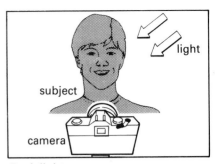

Back light

Light falling directly on to the front of the subject. No shadows. Subject looks 'flat', as the highlights are washed out.

When light falls on to the subject from the side it gives modelling by casting shadows. Texture and form of the subject are revealed. The dark side of the subject can be lightened by positioning a reflector to direct or bounce some of the light back on to this side. (This is called 'fill-in'.)

A light source behind the subject gives a dark, flat silhouette effect. No detail in the subject.

The **quality** of light is whether the light is *hard* and contrasty, as from a direct light source (bright sun), or whether it is *soft*, with little or no contrast, as from a diffused (hazy sun) or indirect light source.

Natural daylight outdoors

Most photographs are taken in daylight. Do not take this type of lighting for granted as it has subtle qualities that can be made use of: for example, it changes according to the time of day.

Changes in light on a sunny spring day

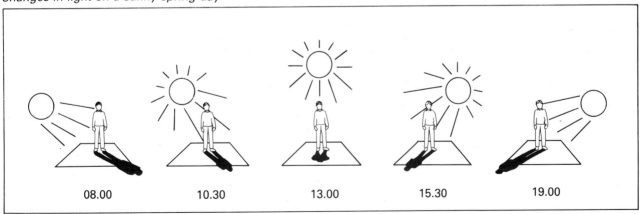

Sun very low in the sky, casting very long shadows. Strength may be further reduced by morning mist.

Sun probably at its brightest and highest position in the sky. The overhead lighting gives very short shadows.

Sun very low in sky. Strength becoming weak. Strong side lighting possible, casting very long shadows.

Time of year

The time of year will alter the lighting. Winter lighting is low in contrast, while mid-summer light is harsh and contrasty.

Type of weather

The type of weather will affect the strength *and* quality of light available. A landscape taken on a bright, sunny day (hard direct lighting, giving strong shadows) will look totally different in mood if taken on a dull, overcast day (soft diffuse lighting – no shadows – giving a flat effect). When the sky is the same tone as the ground it can look dramatic.

Direction of sunlight

The effect of the direction of sunlight can be changed by altering either the position of the subject or camera in relation to the position of the sun in the sky. Thus front, side and back lighting can all easily be arranged with sunlight.

Existing light indoors

Indoors it might appear that there is not enough light present to take a photograph. However, if you can position the subject near a bright window, making use of what light is available, you can usually take a photograph. Care must be taken in determining the correct exposure (see page 27). A reflector on the dark side of the subject will help to lighten the shadows. You may also be able to raise the level of light by switching on electric lights, and even replacing the bulbs with more powerful ones.

Using 400 ASA film, a slow shutter speed and a tripod, it is possible to take shots in almost any indoor lighting, using solely electric lighting, or even by the light of a fire or candle.

In low indoor light levels you can alter the ASA number of your film (uprate) up to 1600 ASA. You must increase the development time (*see your film instructions*) and expect some loss of quality. If you double the ASA number, you increase the speed of the film by one full stop. If the correct exposure using a 400 ASA film is f 2 at 1/60 , then f 2.8 could be used if it was uprated to 800 ASA or f 4 if it was 'pushed' further to 1600 ASA.

Indoor available light photography usually involves slow shutter speeds which are not suitable for photographing movement. However such photographs can capture the realism and mood of an indoor situation and allow the photographer to remain inconspicuous (useful for candid shots). This is difficult using a flash or photofloods! Photographs taken by existing light often have a quality all of their own, quite different from shots using flash or tungsten lighting. They often suppress or lose details in deep shadows, giving a dramatic effect.

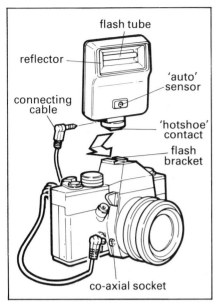

Electronic flashgun

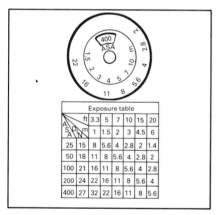

Artificial light: electronic flash

An electronic flash gun is a useful portable light source. It produces an intense short burst of light by discharging electricity across a tube containing an inert gas. The electricity is discharged from a capacitor which stores the energy given from a battery. The gun may give as many as a hundred flashes before the battery becomes flat. The duration of the flash is very short: between 1/1000 s and 1/2000 s.

It is important that the electronic flash gun is used with the specially **synchronised** shutter speed on your camera. With 35 mm SLR focal plane shutters, this is usually 1/60 s (*check your camera instructions*). It is also important that an effective electrical connection is made between the gun and the camera. This can be made either by a cable which plugs into a *flash 'X' socket* (usually by the side of the camera lens), or by a *'hotshoe'* electrical connection which can be part of the *flash mounting bracket*.

When the shutter release button is pressed, the shutter opens. When it is fully open, two electrical contacts come together, completing a circuit that fires the flash. Therefore it is important that the flash is correctly connected and the synchronised shutter speed (or a slower speed) is used, so that the full frame is exposed when the maximum output of the flash is reached. Using too fast a shutter speed will result in only part of the frame being exposed.

The power of a flash gun is expressed by its **guide number**; the bigger the number the more powerful the gun. The guide number for a particular film speed remains constant. If you divide the guide number by the distance in feet between the subject and the camera, you can calculate the correct aperture to use. For example, for 125 ASA film, guide number 80, subject eight feet (2.4 m) from the camera:

Aperture $= \frac{80}{8} = 10$ (f 11 nearest aperture number)

Calculating exposure

When using an electronic flash gun you must use it with the synchronised shutter speed for every shot. This means that *only* the aperture can be changed to give different exposures. *As the subject becomes further away from the flash obviously it will receive less light and require a larger camera aperture. A close subject receives more light and needs a smaller aperture.* This loss of light over an increase of distance is known as 'fall off'. Small guns can often only be used with subjects not more than 6 m away.

The guide number of the flash gun for various speeds of film is usually incorporated on a **chart** or **calculator dial** on the back of the gun. This can be used to determine the correct aperture. Flashguns and their calculator dials can be used in either of two ways:

Manual flash provides a burst of light of exactly the same brightness and duration every time. The calculator dial is first set to the ASA number of the film or alternatively the column relating to that speed of film is found on the chart. You then find the appropriate

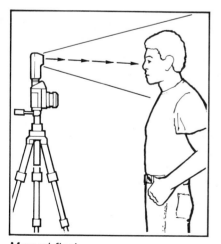

Manual flash

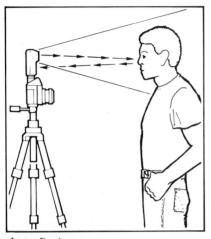

Auto flash

flash-to-subject distance on the distance scale or column. Read off the adjacent correct aperture. The subject distance can be read off the focusing ring of the camera lens if the flash is at the camera position.

Auto (computer) flashguns have a *sensor* that reads the amount of light being reflected back from the subject (similar to the action of an exposure meter). They then adjust the duration of the flash to be brief for close or light-toned subjects, or longer for further or darker-toned subjects. When using the gun automatically, you usually have a choice of two aperture settings: large for distant subjects (or small depth of field); small for close subjects (or greater depth of field). This choice is clearly indicated on the dial or chart by the use of colours.

Manufacturers tend to be optimistic when rating the guide number or calibrating the dials of flashguns. If you find your negatives are consistently underexposed when using the apertures suggested, then try using a stop over (or, if necessary, two stops over) the aperture indicated on the dial or chart.

If ever the recommended aperture falls between two f stop numbers, and you cannot set this on your aperture ring, then set the larger of the two apertures on your camera.

Varying the strength, direction and quality

If necessary, you can use a more or less powerful gun. The strength of light also changes with the distance the flash is held from the subject.

The brief duration of a flash means that it is impossible to see the effect of the lighting. However, the basic effects of front, side and back lighting apply, if the gun is held in these positions.

Side lighting with flash

The quality of flash can be changed by diffusing it, placing a tissue handkerchief or filter over it. Alternatively, it can be made into an indirect light source by **bouncing** (reflecting it) off a white card, wall or ceiling. The technique of bouncing is also a useful way of arranging side or overhead lighting. It gives a soft light. When bouncing flash, the overall subject-to-flash distance is made up of flash-to-wall and wall-to-subject distances.

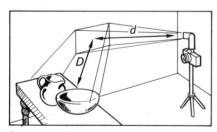

Bouncing flash off a wall

Hints on using flash

If windows, mirrors or spectacles are included in a flash photograph they may reflect back the flash of light quite strongly. Angle such surfaces away from the camera.

Straight-on close-ups of people, using direct flash, usually bleach out their faces and make their eyes look red ('red eye') by illuminating the inside back of their eyes.

When subjects are at different distances from the camera *some* will suffer from fall off. Choose the subject that you want to be exposed correctly, read its distance and use the corresponding aperture.

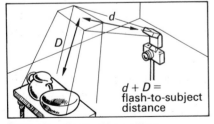

$d + D =$ flash-to-subject distance

Bouncing flash off a ceiling

Flash can be used outdoors to 'fill-in' where a face is in shadow. Arrange the flash for side lighting and soften its light by holding a handkerchief over it. A flashgun can also be the principal light source outdoors if the weather is extremely dull, or at night.

The brief duration of flash makes its use an ideal technique for freezing movement. Use flash to record and freeze difficult fast-moving subjects such as a diver entering water or an athlete running.

Always check that the flashgun is turned off after use. Take the batteries out if you are not going to use the flashgun for some time.

Photoflood (tungsten) lighting

Photofloods have the advantage that once they are switched on you can see the effect of positioning the light. However, unlike portable electronic flashguns, they use a mains electricity supply and are therefore normally restricted to studio use.

It is not necessary to have a photographic studio in order to work with tungsten lighting. You can arrange a simple studio set-up by using a room in which daylight can be excluded as much as possible (drawing curtains or blinds). Organise an unobtrusive or neutral background in front of which you can place your subjects. You could use a large roll of background paper, which has no breaks or joins, or a piece of material which hangs neatly. A white ceiling is useful for 'bouncing' light. Large sheets of card (as **reflectors**) and large sheets of tissue paper or translucent white perspex (as **diffusers**) can also be used.

The photoflood lamp consists of a powerful 'over-run' bulb, behind which is a separate reflector unit. The bulbs are available in two strengths, 250 and 500 watts, and have either screw or bayonet fittings.

As these bulbs glow so brightly and consistently, they have a short working life. The bulbs also generate a lot of heat, so switch off the lamps whenever they are not essential. By changing the type of reflector on the unit, reflecting the light off a card or wall, or diffusing it, you can make the light either 'hard' or 'soft'.

A pair of photofloods is especially suitable for portraits and still-lifes. You can see the direct effect of the light as it falls upon the subject and exposure calculation is straightforward. A hand-held meter is more useful than your camera meter because it is easier to hold it close to the subject.

Copying

Copying allows you to make photographic records of artwork and preserve old prints of which the negatives have been lost.

In most cases the lighting must be as even as possible and you should not introduce any creative photographic or lighting effects. Slow films with fine grain are usually best for copying. Great care must be taken with the positioning of the camera and original artwork or print.

Successful copies are produced when:
1 The camera and lens are exactly parallel to the subject. You will need a flat surface on which to fix the original. It is useful to place the original item on a larger black background. A spirit level can be used to check if the camera is level.

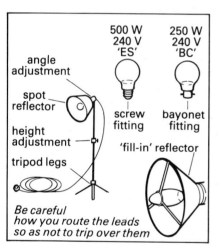

Two studio set-ups

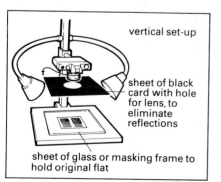

A purpose-built copystand

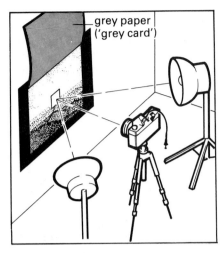

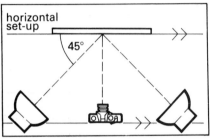

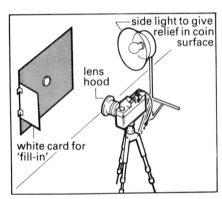

Photographing a coin indoors

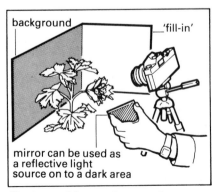

Photographing a plant outdoors

2 The camera is centred and squared up so that the original is framed precisely in the viewfinder. (A small mirror can be taped to the centre of the original and the reflection of the camera can be used to line it up exactly parallel and dead centre to the original.)
3 Focus is sharp from corner to corner.
4 The illumination is even.

Even illumination is achieved when two identical strength photofloods are both at 45° to the original and are at exactly the same distance (and height). String can be used to check the angle and distance of the photofloods.

Check for evenness of illumination by holding a pen at the dead centre of the original. If the shadows are of the same degree of darkness and at the same angle then the lighting is even.

Exposure

Large areas of dark or light tones in the original may mislead your exposure meter. You could place a standard 18% reflectance photographic **grey card** at the subject position which should give a correct reading for mid-tones. You could try comparing an incident reading. Practically, a series of test exposures bracketing at half stops would determine the correct exposure.

Close-ups

Strictly speaking, a **close-up** photograph is one in which the image is between one-tenth life-size (a ratio of 1:10) and life-size (1:1).

Macrophotography (see page 84) is a term usually applied when the subject is magnified in a shot up to about ten times (×10) life-size. For greater magnification than this, objects usually have to be photographed through a microscope — the technique of **microphotography**.

Hints on close-ups

As the depth of field is so shallow, you will need to use small apertures and slow shutter speeds. Using a tripod in close-up work helps cope with this, and the problem of critical focusing.

Indoors, use photofloods, remembering the principles of directional light and fill-in. Use a neutral coloured card if necessary as a backdrop, and a white card or mirror for fill-in. Outdoors, shield such objects as flowers from the wind. Make sure that your shadow does not fall across the picture. A diffused flashgun (you can use a handkerchief) can also be used to illuminate outdoor close-ups.

Close-up photography demands a high degree of precision. You have to solve the problems of critical focusing and a shallow depth of field, lighting and exposure.

The main thing to consider is that for a close-up the distance of the camera lens from the film has to be increased more than normal, so that it can focus the rays from a very close subject. This can be achieved in a number of ways.

Supplementary close-up lens

You can add another lens element (a close-up attachment or lens) to the front of your normal or standard lens. Inexpensive and convenient.

Extension tubes

Increase lens-to-film distance by screwing an extension tube in position, between lens and camera body. Bought in sets of three or more of differing lengths. Can be used in any combination of two or three, or individually. Inexpensive.

Reversing a lens

Some camera systems allow the standard lens to be reversed (by using an adaptor) when the subject is closer than the lens to film distance. Inexpensive, but not so convenient. Performs relatively well.

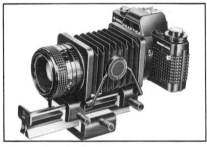

Extension bellows

Increases the film to lens distance smoothly, not by steps, and to a greater length than extension rings. Can be used in conjunction with extension rings for even greater close-ups. Overall length of camera and bellows necessitates use of a tripod.

As the lens-to-film distance increases
1 the depth of field in front of the lens becomes shallower
2 the intensity of the light on the film decreases and *exposure must be increased*

If your camera has a built-in TTL metering system then it should automatically take into account any increase in exposure required by increasing lens to film distance. Otherwise, multiply the exposure by the factor derived from the formula:

$$\text{factor} = (\text{magnification} + 1)^2,$$

where magnification $= \dfrac{\text{image height}}{\text{subject height}}$

Practical things to do . . .

1 Try setting up a simple studio situation with background, sitter or still-life, camera, two floods and reflectors. Remember that tungsten light will be similar in effect to flash or sunlight, when used from the front, side or back. Try each of the set-ups shown below. Compare the results in your pictures with the comments under the pictures. Experiment with some lighting set-ups of your own. Try using a slide projector as a light source: it is useful for dramatic effects. Remember you do not have to use a sitter: you can try photographing a still-life arrangement of objects if you prefer.

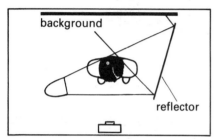

Side light plus reflector for 'fill-in'

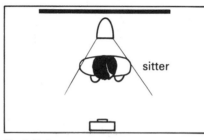

Back light

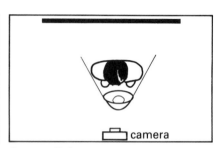

Bottom light

Strong shadows dividing figures into light and dark sides. Dark side can be lightened by adding a 'fill-in' reflector.

Similar to shooting into the sun. Flat, black silhouette effect. With certain hairstyles it is possible to achieve a rim of light around the hair.

An odd effect in a portrait – rather unnatural and menacing.

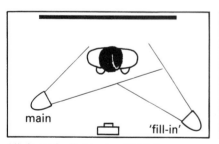

High main light plus 'fill-in'

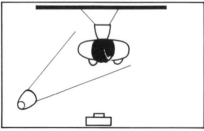

High 45° 'key' light plus background light

Bounce off ceiling

Some modelling of features with shadows softened to a greater or lesser degree by altering angle and distance of 'fill-in' light.

Strong modelling of features, with shadows under nose and chin. Halo of light around subject on background.

Very soft diffuse type of light casting no shadows. Not suitable for portraits.

2 Try producing a copy photograph of a piece of 'artwork', another photograph or a montage. The 'artwork' could be a drawing, a painting, a chart or diagram, a page from a book or magazine, or a poster.

3 Produce a close-up photograph of a very small object such as a flower, a coin, or small electronic component.
4 Construct a still-life backdrop which gives a suitable seamless background and an area in which you can easily control the light.
5 Place a friend, sitting in profile, in front of a translucent screen which is illuminated from behind by a slide projector. Produce a silhouette picture.

Making a backdrop for still-life

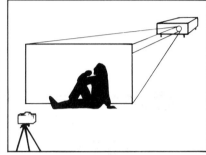

Taking a silhouette picture

6 Produce four photographs of the same subject exploiting the different qualities of the four types of lighting.
7 Produce a set of twelve photographs of a tree taken (a) early in the morning, (b) at midday and (c) at sunset on each of four days during winter, spring, summer and autumn.

Advanced printing techniques

Chapter 5 covered the basic technique of making simple, straightforward prints. However, more advanced printing techniques allow the photographer to control and manipulate the final image in many exciting ways. Such techniques provide an additional means of adding impact to pictures. A selection of these techniques is described in this chapter.

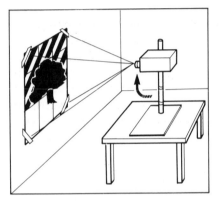

Direct printing techniques

Making giant enlargements

Giant enlargements of a whole negative can bring out details in the image that go unnoticed when standard sized prints are made. Very small details or sections of a negative can be enlarged to become the whole new picture itself. Very large pictures mounted on a wall are often termed **photo murals**.

To make a giant enlargement you will need an enlarger on which you can rotate the head. Either rotate the head through 90° and project the image on a far wall of the darkroom or, alternatively, remove and turn the head around 180° and project on to the floor.

To achieve the size of print you require you may well have to lay out several smaller sheets of paper which overlap, or use two or three strips of paper from a roll (available in 76 cm, 122 cm and 132 cm widths). Processing large rolls of paper may require careful organisation. One method is to dilute the solutions to half strength, double the development time and draw the roll back and forth through the solution in a see-saw motion.

It will probably be necessary to use the lens at maximum aperture to keep the exposure time down. Choose a sharp negative to begin with and do not move about or jar the enlarger during the exposure. Big enlargements increase grain and reduce contrast. Hard grades of paper limit these defects.

baseboard held down firmly by counterweight or clamp

Varying the shape of prints

Do not be restricted by the format of either the 35 mm negative or the available printing paper. A particular image or subject may benefit from a different or unusual shape: for instance, a long horizontal strip for a landscape or a narrow vertical strip for a tree.

The simplest ways of altering the shape are by adjusting the black strips of the masking frame to suit the image or by 'cropping' the paper to shape once the print has been made.

Leave a space at the top of a portrait to avoid the appearance of the head bumping against the frame or border. With a moving subject have the subject moving into the picture with a small space in front of it. Again this is to prevent the subject from touching the border. It also has the added advantage of moving the subject off-centre.

Another technique is to cut out and lay cardboard masks over the paper, adjusted to the composition required. This method produces a shaped image surrounded by white.

Altering exposure times to achieve different effects

By giving a negative a little more or little less than the 'correct' exposure you can change the original effect. By altering both the 'correct' exposure time and grade of paper, dramatic changes can be introduced to a picture. For instance, an original shot of a church against a sky, exposed for detail in the church, can easily be printed as the silhouette of that church against a detailed sky.

Similarly, a picture that was originally lit or observed as being one of dark, sombre tones to express a serious or dramatic mood can be further manipulated by slight overprinting and choice of paper grade. Such a picture is termed **'low-key'**. A **'high-key'** shot is one which contains mainly bright, light tones that complement a delicate mood. Again, by carefully manipulating exposure time and paper grade, the 'high-key' lighting and subject arrangement can be further enhanced.

An unusual format

Increasing the exposure to produce a silhouette

101

'Holding back' and 'burning in'

Quite often a 'straight' print from a negative may look unsatisfactory (for example, the highlights may be bleached out). You can improve upon this by controlling the time given to different parts of the print during exposure. The techniques known as **'holding back'** and **'burning in'** give shorter or longer exposure times to different parts of a negative.

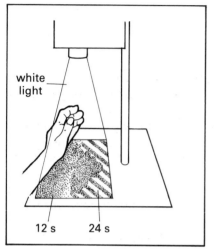

Shading

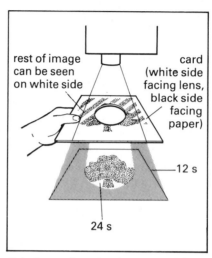

Printing or burning in

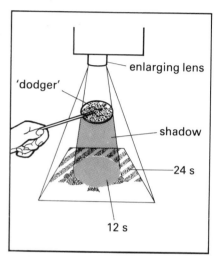

Dodging

Shading can be achieved by holding your hands or a piece of card between the lens and paper. It is a technique used to give more exposure to a broad general area. In this example, a landscape, the correct exposure for the ground was 12 seconds. This gave little detail in the sky. The ground is shaded while the sky is 'burnt in' for an additional 12 seconds exposure time.

By cutting an appropriately shaped hole in a piece of card, shading or 'holding back' an area can be made more accurate. In this negative, the tree is dense and overexposed in relation to the background. This specific area was printed or 'burnt in' for an additional 12 seconds.

A 'dodger' can be made by fixing a cut piece of card or a piece of cotton wool, the approximate shape of the area to be 'dodged' to a stiff piece of wire. It is held over the area to be 'dodged' during the additional exposure time required for the rest of the print. In this negative, the background is dense (overexposed), thus requiring more printing exposure.

It is essential to hold your hands and card well up from the printing paper and keep them moving slightly during additional exposure times. This will prevent hard edges between areas which have been given different exposure times. It is useful to do a test strip for each of the separate halves of such negatives. It is also useful to practise the shading of a particular negative, with the red filter over the lens, before you attempt it.

Few of the accepted master photographers are content with straight prints. They shade, **dodge** or burn in their negatives to achieve very specific effects in a print, such as subduing or highlighting a detail. Such techniques may need to be employed to recapture the reality of the original view.

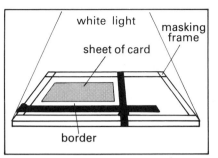

Printing a black border

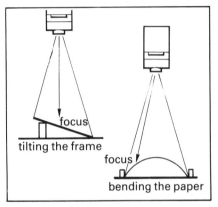

Distorting the image

Black borders

Even after having 'burnt in' parts of a print that have no detail, the white parts may still 'run into' the white paper border. In such cases a black border around the image helps to 'hold-in' the composition.

The black border can be drawn directly on to the print using a pen and straight edge. Glass negative carriers with masking strips are useful in printing a black border around a whole negative. Alternatively, a black border can be printed using a sheet of card as illustrated in the diagram.

Distortions

Converging verticals in an architectural shot can be corrected by tilting the masking frame. However, the resulting image of the building will be elongated.

When tilting the masking frame (or bending the printing paper) a small aperture must be used in order to keep loss of focus to a minimum. Always focus on a point that is half the distance between the nearest and furthest parts of the paper from the lens. The paper that is nearest the enlarger may well be more brightly illuminated than the furthest part of the paper. This may well need a shorter exposure, by 'holding back'.

By printing on curved paper you can achieve amusing distortions similar to those seen in fairground mirrors.

The apparent surface texture of the printed image can be changed by using **texture screens**. These can be bought or improvised.

1 Plastic texture screens or patterned glass can be laid on top of the paper and the image printed through it. The resulting effect suits metallic subjects.
2 Objects or screens can be placed in the negative carrier, and sandwiched against the negative. You could experiment with netting, tissue paper, or nylon stocking. Soft focus effects can be achieved by placing glass, acetate, or perspex smeared with vaseline either in the negative carrier or below the enlarging lens.

Reducing or eliminating tone

It is possible to lose the mid-grey tones of your print in a number of ways to achieve a dramatic, stark, black and white effect. The simplest way is to print on a very hard grade of paper such as 5 or 6. The most successful method of **tone reduction** is achieved when using *lith* film or paper.

Lith (line) film

Lith film is obtainable in either roll or sheet form. It is an **'orthochromatic'** film sensitive to blue and green light, but insensitive to red; therefore a deep red safelight should be used. It can be loaded into cassettes and used like a normal film. However, its ASA number is 6; this restricts its use to a sunny day or with a tripod.

A photograph taken with lith film

If your camera metering system cannot be adjusted to an ASA of 6, you will have to alter the aperture. Experiment with different shutter speeds.

The film can be developed in a standard developing tank. The correct developer is 'Kodalith' but a strong solution of print developer can be used. The same time and dilution as for prints could be taken as a starting point.

Lith, or line film as it is sometimes called, produces an image of line quality, pure black and white, with no intermediate grey tones.

Lith film is also available in 25.4 cm×20.3 cm (10 in×8 in) sheets. Normal 35 mm negative strips can be contact printed on to a sheet of lith film. If this sheet is contact printed and the subsequent sheet cut into strips, normal **'half tone'** 35 mm negatives can be converted into 35 mm line negatives.

You can also use sheet film as if it were printing paper. A normal negative can be enlarged on to a sheet which is contact printed to regain the negative image. Lith film dries quickly. The resulting large 25.4 cm×20.3 cm (10 in×8 in) negative can then be worked upon to 'lose' any unwanted parts of the image. This final retouched negative can then be contact printed to form the final full-size print.

Lith paper

Lith paper can be bought in 100 foot rolls. (An example is Agfa 'Copyline'.) By cutting and loading your negatives into slide mounts you can use a projector to project the image on to cut paper taped to a flat surface. The exposure and development times are short. Normal print developer can be used, and fixing and washing is the same as for bromide paper.

Very large photo-murals can be made by simply moving the projector further away and projecting on to several pieces of paper taped together.

Lith paper produces line images like lith film. However, it is more convenient to use and much larger images are possible.

Solarisation

If the light is accidentally switched on then off, during the development of a print, it can give a solarised effect.

It results in a picture which has the appearance of being part positive and part negative. **Solarisation** should be controlled, rather than accidental, to ensure the best effect.

Choose an image that is sharp and has line quality. Do a test strip and subject it to the following process. Try it on a much harder grade of paper than you would normally use. Half-way through the development, expose the print to a flash (a second or two) from a white light about 3 m above the tray. Complete the development, taking care *not to agitate* the print. Then finish the processing sequence in the normal way.

You have to experiment with the technique of solarisation to achieve satisfactory results.

Solarisation

Working on the finished print

Colouring (or tinting)

A black and white print to which you have added colour by hand will never look as realistic as a colour print or transparency. However, by applying colour yourself you have a high degree of control over what colours you want and where you would like to apply them. Hand-coloured prints can be made very 'eye-catching', especially when only selected parts are coloured and other parts are left black and white.

The best way to colour prints is by using photographic dyes; however, such colouring kits can be expensive. You can try experimenting with paints and felt-tip pens. Colour is best applied to matt prints that have first been dry-mounted. It is difficult to add colour over a black or dark grey; therefore, it may be useful to work on an underexposed print, depending on the finished picture required.

Colouring and toning photographs are techniques often used in advertising and graphics.

Toning

Toning a print is a technique which adds a single colour to the whole print by immersing it in a chemical solution. **Sepia toner** is the most popular, and changes black and greys to the warm, brown tones of Victorian photographs. It works well with suitable images such as old buildings and landscapes. Sepia toner *changes* the black silver image in the paper emulsion to sepia. Other so-called 'toners' (blue, red, green or yellow) work more like dyes, soaking the print in a single dye solution until it absorbs the new colour.

Sepia toning a print involves soaking a properly exposed, developed and fixed print in a bleach solution until the image has almost disappeared. The print is then washed and placed in the toner. The image reappears in sepia. The print is then washed and dried again.

A toned or dyed print can be hand tinted for further effect. Alternatively, by using waterproof masking fluid to cover parts of a print, it can be partly toned. An effect similar to solarisation can be achieved if you partly bleach out the image, leaving some parts black. You can then place it in the toner.

Montage

Montage is the technique of cutting parts of different prints and sticking them together to create a totally new image. The various parts can be stuck down on a background print.

The unreal images, changes of scale, and odd juxtapositions created in this way can be very surprising or humourous. Adding letters and words to a photograph is a common form of montage. It is a technique that has been successfully used in advertising, record covers, and political propaganda for many years.

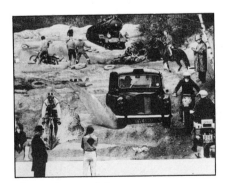

A montage print

105

Choose prints of similar quality and contrast. Matt prints are useful to work with, in order to eliminate the problems of reflections when re-photographing the montage. Spray adhesives are very suitable for montage work. Re-photographing the work is a method of eliminating the joins which can be further hidden by **retouching**.

Improving the appearance of prints

Retouching

Even the most careful worker gets white spots and black marks on prints. These are caused by dust, grit, hairs or scratches on the negative or negative carrier glass. A simple retouching kit might consist of a very fine artist's brush, black photographic retouching dye, black watercolour (or designer's gouache) and a fine pointed scalpel blade in a holder.

To eliminate white marks on a print, dilute a small drop of the black pigment with drops of water until the tone matches the adjacent tones on the print. Then apply minute points of the diluted dye to the white speck, gradually covering the area by imitating the grain structure of the emulsion. You can practise on a similar area of tone using a scrap print. Matt paper is the best to work with, as retouching shows up easily on glossy papers. Sometimes a sharp soft pencil (2B) can be used.

Black marks on a print are best scratched at using a fine scalpel blade. When the emulsion has been scratched completely through, the white paper base will show through. Once the black speck has been converted to a white speck, the tone can be built up using a brush or pencil.

Professional photographers often heavily retouch a printed image in order to achieve a specific or improved effect. For instance, a spot or wrinkle can be eliminated from a film star's face, or wires supporting a 'flying' person can be removed from the picture.

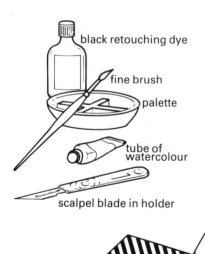

black retouching dye

fine brush

palette

tube of watercolour

scalpel blade in holder

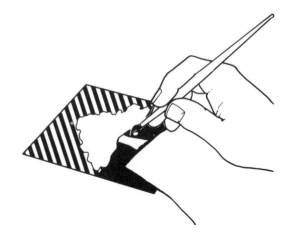

Mounting

Mounting your prints will display them to their best advantage. Mounted prints are easier to store and keep in good condition.

A convenient way of *storing* prints is to mount them on card and keep them in a folder or box. They can then easily be displayed at a moment's notice. Another way is to punch holes in the card and store the prints in a ring binder. Using photocorners to hold them in an album is a very popular method of keeping prints. Whichever method you choose, keep up to date with mounting your pictures.

Various adhesives can be used to mount your pictures on to card. A spirit-based glue (e.g. 'Cow Gum') can be carefully and evenly spread on both the back of the print and the card. Allow the glue 5–10 minutes to dry and then stick the two surfaces together. Rub the print down flat using a clean cloth. This method is time-consuming, so organise your prints into a production line. Spirit-based glues have the advantage that excess glue can be gently rubbed off. Some glues dry leaving hardened lumps behind your print, which will show through. *Spirit-based glues should be used only in well ventilated rooms.*

Dry mounting is probably the best method of mounting your work. However, it involves using an expensive dry mounting press and dry mounting tissue. It is also time consuming, but mounts your prints perfectly flat. Dry mounting tissue is bonded in a shellac adhesive on both sides that bonds permanently when heat is applied to it. A sandwich is made with a print on top, dry mounting tissue cut to exactly the same size in the middle, and then the card underneath. The sandwich is then put in a dry mounting press. Heat and pressure are applied for about a minute. The print leaves the press permanently bonded to the card. Difficulties arise with large prints and sheets of card which have to be put in the press in overlapping sections.

Spray mountants in aerosol cans and double sided sticking tape are mounting methods regularly used by graphic artists. They are being used increasingly by photographers to mount prints on card. They are not such thorough methods as spirit-based glue and dry mounting but they do have the big advantage of being both quick and convenient.

Hints on mounting

When using mounting board, choose a suitable range of colours or tones. Bright colours will distract viewers from the picture. Mid grey is suitable for both dark and light prints. Black is good for lighter prints and light tones for darker ones.

The size of borders is important: too big and the prints will look isolated; too small and the prints will look cramped. A 12.7 cm×17.7 cm (5 in×7 in) print on A4 size card gives a generous border. With smaller prints you could standardise on a certain width border (e.g. 30 mm) all the way round.

Mounting more than one print on a large sheet of card (A2) can be convenient. It is especially suitable for prints which form a group, complementing each other. For instance, a set of photographs taken on a theme, or of the same subject.

When mounting prints always take care to mount them straight, with an equal border all the way round. You can measure the borders with a ruler, or use quicker methods, such as the two illustrated. Although borders of the same width all round are normally used, it is quite acceptable to make the bottom one slightly wider, particularly if a title is to be added. On a big enlargement the picture sometimes appears to be slipping out of the frame; a wider bottom border counteracts this.

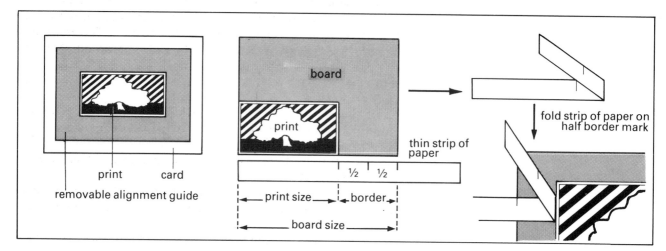

Display

The importance of these final stages of retouching, mounting and displaying your work should never be underestimated.

Your display is a culmination of a long period of work, and the examiner or viewer will always be affected by how well the photographs are displayed. Your prints should be displayed to their best advantage, and care and thought must be taken over their arrangement.

Faced with a large empty area it might be difficult to know where to start. A drawing on graph paper can be an aid to the positioning and grouping of your prints.

The 'rules' of composition can be an aid in helping you to arrange your display. The ideas of positioning, balance, symmetry and asymmetry apply equally to display work. An effective display should add up to a coherent whole, show a progression of ideas or themes, and convey such ideas clearly.

As a lead-up to an important display, it is useful to have regular informal displays of current work. Prints can be pinned on to a piece of soft board. Such displays can be an objective guide as to how you are progressing and can lead to constructive criticism from your teacher or group. *Photographs are, after all, meant to be looked at (and talked about).*

Practical things to do . . .

1 Make four prints, increasing the exposure time slightly each time, thus making each print gradually darker. Mount them in a row and examine the results.

2 Make a print of a picture which contains an interesting shape or pattern. Reverse the negative in the negative carrier and make another print, using the same exposure time. If you make two copies of each print you can cut and mount them to form a radiating pattern similar to a kaleidoscope.

3 Try sandwiching two negatives (complementary pictures, if possible) together in the negative carrier for a superimposed (double) image. Do a test strip to determine the correct exposure.

4 Repeatedly move the masking frame in small steps during the printing exposure. Move it in the same direction. The multiple image effect obtained can create a feeling of movement if done with pictures of cars, birds, etc.

5 Try zooming the focus control during exposure for an unusual effect of movement.

6 Cut a print into strips of the same width. Reposition the strips slightly out of line so they don't quite match up. The finished piece can be trimmed around the edges.

7 Cut up two prints of the same subject and paste down for a stretched-out effect.

8 Take two prints of contrasting subjects and carefully cut them into the same width strips. These can be remounted with alternate strips from the two different prints.

9 Make a print from a negative on a hard grade of paper (e.g. 5). Make a paper negative of your print by contacting it on to another sheet of paper of the same grade. This paper negative can then be contact printed to obtain a positive image. This process can be repeated until you lose the grey tones completely.

Suggestions for further work

History of photography

While the history of photography is part of an 'O' level photography course, the CSE student is not normally required to study this aspect of the subject. However, some study of the technical and artistic developments over the past 150 years will deepen your understanding of photography at its present stage of development.

Photographic appreciation

Looking at photographs in books, magazines, and newspapers may spark off ideas which could be applied to your own shots. Little can be gained from slavishly copying another picture. If you find a particular photograph interesting or exciting, try to analyse the reasons why the picture is successful (or not, as the case may be). Bear these reasons in mind when working yourself.

Visits

Visiting photographic exhibitions is another means of appreciating photographs. It can be argued that hanging photographs behind glass on an exhibition wall is seeing them out of context. However, viewing photographs at an exhibition has the advantage that you will see them full-size and displaying their richness and depth of tone. Both these qualities tend to be lost when photographs are printed in a book or magazine, unless they were originally intended for this and the printing is of good quality. Whether you see photographs in books or at exhibitions, there is no substitute for looking at photographs, and analysing and discussing them.

There are a number of museums that house important collections of photographic equipment. They too are well worth a visit.

Photography at school

Photography can record various aspects of school life. Recording such school events as displays, school plays and concerts, sports, school journeys, open and speech days can be a challenge to your skill.

Photography can be used as an aid to study by including pictures in project work for such subject areas as local history, nature study and social studies. It can be used as a tool in technology, science and craft; for recording experiments using macrophotography and microphotography; for photographing work at various stages of production in the school workshops.

Further study

It is possible to study photography at 'A' level and at college on either a full or part time basis. Consult:
Where to Study? The B.J. Directory of Photographic Education compiled by E. Martin (Henry Greenwood and Co. Ltd.) ISBN 0 900414 23 5.

Careers

If you have become really interested in photography why don't you find out what career opportunities are available. Consult:
Photographic Careers by E.G. Southey (Fountain Press) ISBN 0 852 42641 0.
Working in Photography by Ilott and Naylor (Batsford) ISBN 0 713 43311 6
British Institute of Professional Photographers, Amwell End, Ware, Herts, SG12 9HN.

Current and future technology

Technology is advancing at a very fast pace. A number of important developments are taking place in photography. Find out all you can about the following topics:

1. Fully automatic cameras
2. Zoom lenses
3. Auto winding (film transport)
4. Automatic focusing
5. Polaroid cameras and films
6. Multi-grade printing papers
7. 3D cameras
8. Chromogenic 'silverless' films e.g. Ilford XPI or Agfa Vario-XL
9. Electronic video recording equipment
10. Cibachrome colour prints
11. Kodak Ektaflex PCT colour print making system
12. Holography
13. Sony Mavica camera
14. Kodak Disc cameras
15. 400 and 1000 ASA colour negative films

Appendix

Negative faults

After processing your negatives, examine them closely to see that they are satisfactory. You may find that a negative has one of the following faults:

Underexposed negative

Overexposed negative

This negative is pale and thin, giving little shadow detail and only recording the highlights. A 'hard' negative. Print on a 'soft' paper.

This negative is dense and black giving plenty of shadow detail, but overall it is flat and lacks contrast A 'soft' negative. Print on 'hard' paper.

Normal negative

Underdeveloped negative

Overdeveloped negative

This shows a full range of tones. The highlights are strong yet transparent. Shadow detail is present. Density and contrast are normal. Print on a normal grade of paper (2 or 3).

Such negatives are pale and thin. They differ from underexposed negatives in that shadow detail is present but highlights lack adequate density. Low in contrast. Print on a 'hard' paper.

These are dense and black but differ from overexposed negatives in their extreme contrast. Print on a 'soft' paper.

Crescent-shaped marks

Drying marks

Finger marks, scratches and dirt

These dark half moon shapes are caused when the film is 'crinkled', usually when loading it into the spiral. If it sticks when loading, never force it. Always use a spiral that has been thoroughly washed and dried.

Irregular light patches caused by drops of water drying on the emulsion. These marks cannot be removed by re-washing. Always use wetting agent and wipe the film before hanging it up.

Clean your hands before handling film and hold it only by the edges. Grease or chemicals on the emulsion can be impossible to remove. Dirt or scum in the solutions can stick to the negative, as can dust, hairs, etc, when the film is wet.

Reticulation

Film incorrectly loaded

Not enough solution

Extreme graininess due to the emulsion contracting and cracking. This happens when the film is placed in a solution that is too hot (usually the developer), then into one that is too cold.

Here the film has been incorrectly loaded in the spiral and two surfaces have stuck togethr. This prevents complete processing of this part. If you have trouble in loading, take the film out and try again. Always wind the leader fully in.

If a band of your film is underdeveloped, either not enough developer was mixed to cover the film, or the spiral has slipped up the column during agitation. Don't forget the ring collar. Don't forget if you have two films in the tank!

Other faults include: insufficient washing, insufficient fixing, streaming caused by insufficient agitation in the developer, stale or exhausted developer, 'air bells' (tap tank after pouring developer in), spots caused by undissolved powder chemicals, uneven development caused by over-agitation, and fogging (faulty tank, lid not on correctly, etc.).

Print faults

After processing your prints, examine them closely to see that they are satisfactory. You may sometimes find that a print has one of the following common faults:

Underexposed print

Caused by too little light. Increase exposure time or use larger aperture.

Overexposed print

Caused by too much light. Reduce exposure time or use smaller aperture.

Incorrect focus

Focus carefully using the lens at maximum aperture. Focus on the back of a scrap print. Focus finders can be very helpful.

Enlarger shake

Make sure that the enlarger is on a rigid surface. Avoid touching it, or moving about, during exposure time.

Masking frame moved

Do not accidentally move the masking frame once you have set it up, or during exposure time.

Fingerprints

These can be caused by dirty, wet, greasy, or chemically contaminated fingers.

Uneven development

Caused by insufficient agitation in developer or prints sticking together in developer tray.

Fogging

If all over, caused by light being switched on. Caused by paper box lid being left off!

Red filter covering enlarger lens

Results in a blank or partly exposed sheet.

Other faults include: dirty negatives, lenses, and negative carriers; insufficient fixing; blank paper, caused by using it emulsion side down; black paper, caused by forgetting to stop the lens down; uneven development caused by overexposing and 'snatching' the print out of the developer early; negative in upside-down; uneven borders caused by the paper being placed crooked in the masking frame; too small an image; staining caused by too long in the fix; and insufficient fixing and washing.

Paper scratched with tongs

The resin coating of RC papers is easily scratched when it is wet.

Camera operating faults

Incorrect focusing

Main subject will appear blurred. Some part of the image may be sharp. More a problem with rangefinder cameras; with SLRs this could result from accidentally moving the focusing ring. If necessary move the camera to find a 'sharp edge' to focus on.

Camera shake

The whole of the picture will be blurred or show double images. Hold the camera correctly. Select the highest shutter speed possible. Rest the camera, if necessary, on a suitable surface. Use a tripod.

Lens flare

This is caused by pointing the camera straight at the sun. It will burn away a portion of the image or show hexagonal bright marks. Lens coatings overcome the problem to some extent. Be careful with telephoto lenses. Use a lens hood. Position an object between the lens and the sun.

115

Other camera operating faults

First frame solid black – rest of film transparent.	Film incorrectly loaded. Sprockets not engaging in sprocket holes; when wound-on, film was not moving and all the pictures were taken on the same frame.	Wind through part of the film with the back open. Also, check that the rewind lever is revolving when you wind the film on.
Film ripped in half, with jagged end.	After finishing the film, great force has been used in continuing to wind on the film. The film will either be pulled out of the cassette case, or rip, as in this case.	Always remember to set your film counter, and check it constantly. Make sure you know the number of exposures obtainable on your length of film. Never force the wind-on lever.
The film is completely black, or opaque grey.	The film has been wound on too far, as above, and pulled off the spool. It is in the right-hand side of the film chamber, so winding back is ineffective and opening the camera back exposes the film.	As above. If in doubt, always open camera back in a darkroom or an emergency changing bag. Carry a light-tight tin in your changing bag, into which to unload a doubtful film.
The film has wide black bands from edge to edge, or small streaks of black.	The film has been wound on too far, and the back opened, but closed again quickly. Only part of the film is fogged, causing black strips on the developed film. Light can also seep into the felt light-trap of an old cassette.	As above. Some frames, or parts of them, may be usable. Discard cassettes with worn light-traps – apart from letting in light, they can also scratch your films.
The film is ripped through along the perforations, leaving a jagged edge.	The film has been wound back without pressing the rewind button. Using force has resulted in the film being ripped along the sprocket holes, making it difficult to load into the developing tank.	Remember to press in the rewind button, and to hold it in if necessary. Extreme stiffness in using the rewind lever will tell you that something is wrong.
The film has parallel scratch lines running along it.	Parallel scratches through the film (known as tramlines) are caused by dirt or grit on the pressure plate, chips of film in the camera body, or grit in the cassette lip.	Periodically clean out the inside of your film chamber, check cassettes and also check your film wiping tongs – they can cause similar damage if dirty.

Note: when film is exposed to light, it turns opaque grey; if developed, it turns black. If you develop an unused film it will turn out completely transparent. A film that has been run through a rangefinder camera with the lens cap left in place will show black end(s) and a transparent middle.

Index

This index lists most of the technical terms that are printed in **bold type** in the text. You may find that it also serves as a useful checklist for revision.

PRACTICAL
PHOTOGRAPHY

Other titles in this series

The Car by E. F. Scott and B. Toby
Houses and Homes by M. R. Jordan and R. E. Hosking